ITALIAN
RENAISSANCE
PAINTING

ITALIAN RENAISSANCE PAINTING

Sara Elliott

Phaidon Press Limited
2 Kensington Square, London W8 5EP

First published 1993
This hardback edition first published 1994
© Phaidon Press Limited 1993

A CIP catalogue record for this book is available from the
British Library

ISBN 0 7148 3238 3

Printed in Singapore

Cover illustrations:
Front: Sandro Botticelli *The Birth of Venus*, c.1490 (Detail).
Florence, Uffizi (Plate 26)
Back: Giovanni Bellini *The Doge Leonardo Loredan*, c.1501-5. London,
National Gallery (Plate 27)

The publishers would like to thank all those museum authorities and
private owners who have kindly allowed works in their possession to
be reproduced.

Italian Renaissance Painting

Renaissance man became modern by looking at his classical past. The medieval and modern worlds had been straddled by the Florentine poet, Petrarch (1304-74), with his classical scholarship, understanding of the achievements of ancient Rome, and scorn of the subsequent 'dark ages'. This new vision, together with his observation and love of nature, provided the intellectual stimulus for the Renaissance in the next century.

In 1492, the humanist scholar Marsilio Ficino conveyed the excitement of the new age in a letter to Paul of Middelburg: 'This century, like a golden age, has restored to light the liberal arts, which were almost extinct: grammar, poetry, rhetoric, painting, sculpture, architecture, music, the ancient singing of songs to the Orphic lyre, and all this in Florence. Achieving what had been honoured by the ancients, but almost forgotten since, the age has joined wisdom with eloquence, and prudence with the military art ...'

The term 'Renaissance', literally re-birth, was not used until the nineteenth century, but Giorgio Vasari (1511-74), the painter and art historian, used the idea of a re-birth of antiquity to describe the extraordinary development – or linear progression, as he saw it – of art from seeds sown by Giotto (1266/7-1337) to maturity in Michelangelo (1475-1564). Of course art did not develop with the consistency Vasari would have us believe, but it certainly evolved through a growing interest in classical antiquities, continually enriched by new discoveries. The humanist's revival of classical studies influenced the subject-matter of works of art. Technical advances in the use of oil paint and single-point perspective, as well as a scientific basis for naturalism, increased the dramatic possibilities of design. The widespread dissemination of modern and classical ideas was due to the invention of printing. Slowly, through the writings of humanists, artists were given the respect they were accorded in antiquity: King Francis I of France was supposed to have held the dying Leonardo in his arms, and Titian was knighted by the Holy Roman Emperor, Charles V. The role of art changed too. The rising interest in collecting fostered new secular art forms, including the revival from the antique of medals, equestrian statues and small bronzes. The idea of the 'work of art' began to emerge.

The *quattrocento* (fifteenth century) was a period of war. Absolute monarchies were emerging throughout Europe, but Italy remained divided into small quarrelsome republics, oligarchies and princely states not even united by a common language. This had three important consequences: first, the peninsula was in a permanent state of internecine strife, complicated by invasions by France and the Holy Roman Empire; secondly, the states developed different characteristics – Byzantine elements lingered in Venice because of the city's Eastern trading links, while in neglected and decaying Rome art was moribund until the election of the 'humanist Pope' Nicholas V (1447-

Fig. 1
Roman copy (discovered 1506) of the Laocöon Group
c.160-130 BC
Vatican Museum

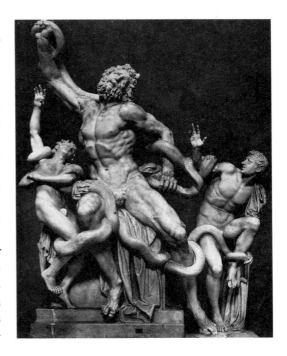

5

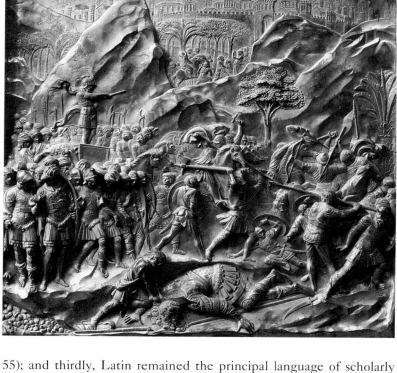

Fig. 2
Lorenzo Ghiberti
The Sacrifice of Isaac
(competition panel)
1401-2. Bronze,
52 x 45 cm.
Florence, Bargello

Fig. 3
Lorenzo Ghiberti
David Slaying Goliath
1425-36. Gilt bronze
panel, 79 x 79 cm.
Florence, Baptistery

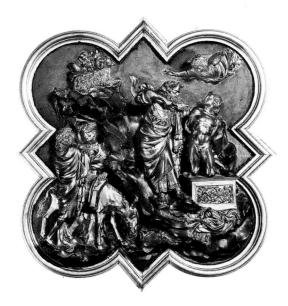

55); and thirdly, Latin remained the principal language of scholarly communication.

While republics rose and fell, some rulers, such as Federigo da Montefeltro of Urbino, a *condottiere* or mercenary who fought for money, amassed great wealth and were able to combine military prowess with a highly cultured life. (The devastating Sack of Rome by Imperial troops in 1527 was a rare instance of war affecting the lives of ordinary civilians.) Despite the wars, the arts flourished in the *quattrocento*, benefiting from four main sources of patronage: the Church (though often altarpieces and decorations were commissioned by individuals); the courts, where painters such as Leonardo in Milan and Mantegna in Mantua would be expected to turn their talents to all aspects of artistic activity; wealthy individuals, mainly commissioning devotional images, portraits, and domestic decorations such as *cassone* (marriage chests); and finally the public, in the form of guilds, confraternities and the State. The mercantile republics of Venice and Florence extended their patronage through competitions.

Most of the new developments in art and learning took place in Florence, which around 1400 was enjoying relative peace and economic prosperity. A republic, the city was governed by its guild members, the creators of its wealth. From 1378, when a turbulent uprising among the *Ciompi* (wool-workers) resulted in brief popular representation, the government became increasingly oligarchic to protect itself from the populace, culminating in 1434 with total control by Cosimo de'Medici, whose successors ruled Florence unopposed until the expulsion of Lorenzo's son, Piero, in 1494, when there was a brief revival of the Republic.

Florence became the centre of humanist learning which covered grammar, rhetoric, history, poetry and moral philosophy. Humanism became inseparably linked with high office in Florence with the appointment as Chancellor in 1375 of Coluccio Salutati (1331-1406), a friend of Petrarch. The office was held by a succession of brilliant men who equated Florence with republican rather than Imperial Rome. While in princely states intellectual life revolved about the courts, in

Florence only the educated patricians were involved in humanist discussions, but the citizens shared in the benefits of enlightened civic life. The confidence of the new age was reflected in the great commissions of the early *quattrocento* for which the Florentine guilds were responsible.

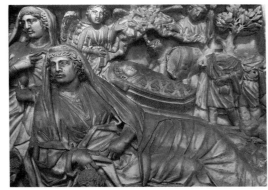

Fig. 4
Nicola Pisano
Detail from the
Nativity panel on
carved pulpit
1260. Marble,
85 x 113 cm.
Pisa, Baptistery

The Visconti of Milan's unsuccessful invasion in 1402 was represented by Salutati as the victory of Florentine civil liberty over despotic oppression. To celebrate this optimism, the *Calimala* (cloth guild) organized a competition to build the bronze doors of the Baptistery. The competition panels of Filippo Brunelleschi (1377-1446), who trained as a goldsmith and later became an architect, and Lorenzo Ghiberti (1378-1455) who won, survive (Fig. 2). While not achieving Brunelleschi's dramatic storytelling, Ghiberti amalgamated Gothic linear patterns and figures based on the antique with a technical virtuosity that Brunelleschi lacked. His assistant on the first doors (made 1403-24) was the young Donatello (1386-1466), who was to create a new type of sculpture; by the time he completed his second set of doors (1425-52) Ghiberti had absorbed the new classicism of Donatello's work (Fig. 3). Artists had of course looked at classical sculpture before – the fourteenth-century pulpits by the Pisanos in Pisa showed an awareness of the antique sarcophagi there (Fig. 4). However, Brunelleschi and Donatello, rather than merely quoting ancient forms, applied the studies they had made in Rome to contemporary problems, bringing a new naturalism to their art. Its likeness to nature was the barometer by which all art was judged in the *quattrocento*. The implied movement in Donatello's statue of Saint George (1415; Fig. 5) gives it powerful realism and naturalness, portraying the noble dignity and heroism of the knight on a human scale. The panel depicts the Saint's triumph over the dragon, and Donatello's use of low relief has an almost painterly control of light, shade and perspective. Donatello's work from the years he spent in Padua from 1443 was to have an important influence on Mantegna and, through his brother-in-law, Bellini, on Venetian art.

Brunelleschi heralded a new mood in architecture with his solution to the seemingly impossible problem of how to build the octagonal cupola for the Duomo, commissioned by the *Arte della Lana* (wool guild). This was largely one of structural engineering, but required the understanding of the forms and construction of classical architecture as well as a grasp of Gothic and Romanesque methods of vaulting. In the Pazzi Chapel, Brunelleschi used classical forms freely and invented a new idiom, *all'antica*: white walls divided by grey columns and pilasters, based on pure geometric proportion and modular repetition (Fig. 6); the effect was of simplicity and restraint. However, it was the exiled Florentine theorist, architect and humanist, Leon Battista Alberti (1404-72) who, in his *De re aedificatoria* (1485), codified for Renaissance architects the classical language of orders as described by Vitruvius, the author of the only architectural treatise to survive from antiquity. Alberti was employed in the Papal Curia and returned to Florence in the train of Eugenius IV in 1434. There he found that the new classically inspired style had taken root in the work of Donatello, Brunelleschi, Ghiberti, the sculptor Luca della Robbia (1400-82) and the painter, Masaccio (1401-c.28). To these men Alberti dedicated his treatise on painting, *della pittura* (1436). No painter other than Masaccio satisfied him, although Alberti would later find an artist, Piero della Francesca (active 1439-78, died 1492), who would embody his approach to painting. This treatise did much to promote the artist as superior to the artisan, stating that the painter should be acquainted

Fig. 5
Donatello
Saint George
c.1416. Marble, height
of figure 209 cm.
Florence, Bargello

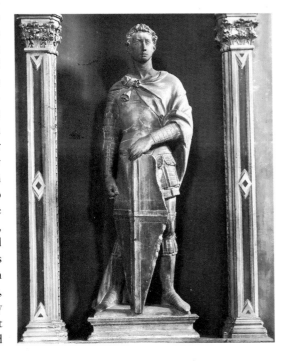

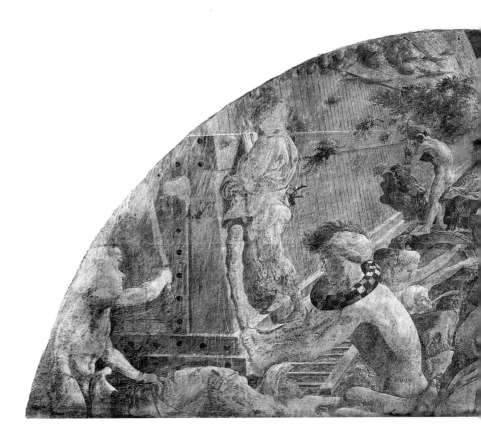

Fig. 6
Filippo
Brunelleschi
Interior of the
Pazzi Chapel
Begun c.1430. Florence,
Santa Croce

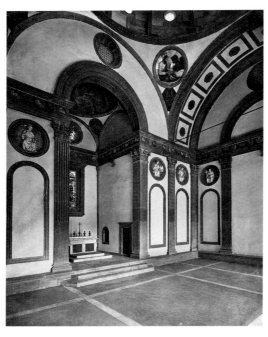

with all forms of knowledge, particularly history, poetry and mathematics. So immersed was Alberti in antiquity that he wrote of 'temples' and 'gods' and classical subjects at a time when virtually none had been painted. In *della pittura* Alberti also offered the artist practical advice on discovering ideal beauty, which lies in the imperfect forms of nature; while one should select from nature to create a perfect form, it was to be remembered that a face is made interesting by its imperfections; 'a history,' he wrote, 'is moving when men express in actions the motions of their minds.' Alberti anticipated later practices of painting the nude – suggesting that movement be expressed by draperies blown by a wind god, as in antique sculpture (Plate 26). He rejected the medieval symbolic and decorative concept of colour, seeing it instead as a function of light, advocated a limited range of hues, and was against gold because it upset the atmospheric unity by reflecting light. His scientific approach appealed to Leonardo, who used passages of the treatise in his own *Trattato della Pittura* (published from notes in 1651).

At the beginning of the *quattrocento*, two challenges existed to the current style derived from Giotto. One, the courtly, sophisticated and decorative International Gothic style had spread from the court of the Dukes of Burgundy, to which Florence was linked by the wool trade. The work of International Gothic painters, represented in Italy by Gentile da Fabriano, Gentile Bellini and Pisanello, reflected their medieval origin in a combination of Gothic linearity and use of symbol, but added a new close observation of nature (Fig. 7). The second was the style of more truthful realism created in painting by Masaccio and in sculpture by Donatello. Despite Alberti's approbation, Masaccio's new realism was not necessarily the most popular – Palla Strozzi commissioned *The Adoration of the Magi* (Plate 4) from Gentile da Fabriano, a representation of the glittering world with which he wished to be associated.

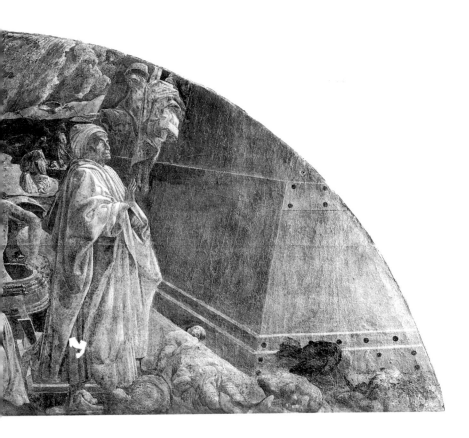

Fig. 8
Paolo Uccello
The Deluge and
the Recession of
the Waters
c.1445. Fresco. Florence,
Santa Maria Novella

Fig. 7
Antonio Pisanello
Study of Monkeys
c.1430-34. Pen and ink.
Paris. Musée du Louvre

Masaccio died in his twenties after painting only three major commissions. These were a polyptych altarpiece for a church in Pisa (Plate 2); the *Lives of Saints Peter and Paul* in the Brancacci Chapel, Florence (Fig 21) – of major importance, according to Vasari, because 'all the most celebrated sculptors and painters since Masaccio's day have become excellent and illustrious by studying their art in this chapel' – and *The Trinity* (Plate 1) in Santa Maria Novella. In a few years he revolutionized Florentine painting, deriving a new nobility for his monumental figures from Donatello's sculpture, and the technical means to portray them from the revived antique science of perspective, which he was reputedly taught by Brunelleschi. Whereas certain traditional elements are shared, a comparison between his Madonna and Child (Plate 2) and Gentile da Fabriano's version (Fig. 22) illustrates the breakthroughs made by Masaccio. His natural figures sit in an actual space created by unified light and perspective. The holy figures are humanized, unlike the ethereal figures populating the awesome medieval Heaven. The difference between Gentile and Masaccio is more than the imitation of nature, it is the essence of the preoccupations of the Renaissance artist.

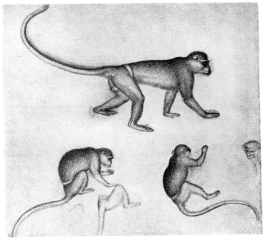

The struggle to assimilate Alberti's ideas is apparent in the work of Paolo Uccello (1397-1475). He was trained in the International Gothic style and worked on Ghiberti's first doors. Vasari thought him 'captivating and imaginative' but deplored his exclusive devotion to perspective. Between painting his Gothic frescoes and the *Deluge* (Fig. 8) in the Green Cloister of Santa Maria Novella, Uccello had read Alberti. His *Deluge*, a virtuoso display of perspective and foreshortening, shows Alberti's powerful influence. In the end, Uccello's love of pattern reasserted itself and his three great battle scenes (Plate 14), while continuing to demonstrate his obsession, are the pictorial equivalent of medieval tapestries, with poetic depictions of the Tuscan countryside and decorative arrangements of weapons, horses and trees, quite unrelated to the ferocity of battle.

The sense of atmosphere that could be achieved by the manipulation of light and colour was the aspect of Alberti's treatise that was appreciated by Piero della Francesca and his Venetian master, Domenico Veneziano (active c.1438-61). Although Vasari's claim that Domenico brought oil painting to Tuscany is untrue, it illustrates his theory about the Venetians' obsession with *colore* (colour) and the Florentines' with *disegno* (drawing): in Florence it was the contour and vibrant line of Donatello's work that was taken up by the next generation, Filippo Lippi (active c.1432-69), Andrea del Castagno (active c.1442-57) and Sandro Botticelli (1445-1510), rather than Masaccio's use of light and colour to mould forms. Between 1445-47 Domenico painted the *Saint Lucy Altarpiece* (Plate 8). The elegance of the figures and the depiction of the Bishop's embroidered cloak show Domenico's lingering debt to the International Gothic; the wiriness of the Baptist's form reflects Castagno's Donatellesque realism; but the limpid colouring and natural lighting bathing the scene are Domenico's own. Piero was to develop this subtle handling of colour modified by light and synthesize it with a northern enamel-like precision.

The *Saint Lucy Altarpiece* was a new form (now called a *Sacra Conversazione*, or Holy conversation) showing saints in a more intimate setting with the Madonna and Child, standing in a sunlit loggia. The purpose of altarpieces was specifically laid down by the Church: they should instruct simple people, and the example of the saints should linger in the memory and excite feelings of devotion. The straightforward didactic work of Fra Angelico (c.1387/1400-55) fulfilled these purposes and reflected his own intense devotion. He was a Dominican friar who lived like the Franciscans as a mendicant preacher, and, although a contemporary of Masaccio and Donatello, he probably only started painting in the late 1420s. His paintings in the cells of the convent of San Marco were intended to inspire devotion and meditation, and remained closer to International Gothic than his frescoes in the chapel of Nicholas V (Plate 5).

Fra Filippo Lippi, a Carmelite monk, was placed in the monastery as an orphan, and took his orders more lightly than the 'blessed' Angelico. His unfitness for religious life is described in Vasari's accounts of his numerous amorous escapades. Lippi is best known for his Madonnas (Plate 3) and his portrayal of ideal female beauty which was continued by his pupil, Botticelli. Lippi's *Barbadori Altarpiece* (Fig. 23), one of the earliest dated examples of the *Sacra Conversazione*, explores the play of picture plane and space. The painted columns continue into the frame, thrusting the kneeling saints into the spectator's space. He was particularly influenced by Donatello's 'ugly-realism'. The surface texture of his pictures is elaborate and his attention to detail suggests contact with the art of Jan van Eyck. For the altarpiece at Santa Margherita, Prato, a Carmelite novice, Lucrezia Buti, posed as Our Lady. Lippi began a scandalous affair with her, and their son Filippino (1457-1504) also became a painter.

By the 1450s and 1460s the great innovations in painting were taking place outside Florence, in the courts of Mantua and Urbino. Whereas in Florence humanism had inspired the civic man and administrator, in the courts of northern Italy a more aristocratic culture flourished. Ludovico Gonzaga (1412-78), who became Marquis of Mantua in 1444, was just, pious and learned, closely in touch with Medicean Florence and particularly interested in architecture, employing Alberti on various Mantuan building projects. The magnificent court of the Gonzaga's Este relations at Ferrara was famous for literature, notably Ariosto's epic poem *Orlando Furioso* (1516). Their

sophistication was reflected in the esoteric art of their court painter, Cosimo Tura (active c.1450-95; Plate 18).

At Urbino Federigo da Montefeltro (Duke from 1474) epitomized Renaissance ideals. He combined expertise in war – where he was praised for his magnanimity and courage – and learning in all branches of art and philosophy. The luminous interior and courtyard of his forti-fied palace at Urbino, by Luciano di Laurana, is one of the purest and most harmonious creations of the Renaissance. It is the setting for Baldassare Castiglione's book *Il cortegiano* (*The Courtier*, 1500-18, pub-lished 1528), which re-creates the atmosphere of the cultivated society of the courtier, whose accomplishments are borne with *sprezzatura* or unforced ease, and which was to become the model for generations of gentlemen. The individual styles of these three courts were linked by a series of dynastic marriages; Isabella d'Este married Francesco Gonzaga and his sister Elisabetta married Guidobaldo da Montefeltro: both women were themselves considerable patrons.

As Piero della Francesca never returned to Florence after the 1440s, he made less impact there than in Ferrara, Rimini and Urbino. Borgo Sansepolcro, where he was born and lived most of his life, had little cultural heritage; his style was formed by the combined influ-ence of early Florentine painting, his own interest in mathematics, and observation of natural detail which in turn attracted him to Netherlandish painting and the use of oil paint. His understanding of mathematical purity of form and unparalleled sense of colour and light created an art of apparent simplicity which is timeless and serene. Piero's interest in northern painting was aroused by the van Eyck owned by Federigo da Montefeltro and the Rogier van der Weyden by Lionello d'Este. In 1451 he collaborated with Alberti on the Tempio Malatestiano for Sigismondo Malatesta, the tyrannical 'Wolf' of Rimini, after which an Albertian influence informed all his works.

Before he returned to Borgo in 1453, Piero painted the *Flagellation* in Urbino. There has been much speculation as to the meaning of the picture and the role of the three figures conversing in the foreground. Analysis has shown the tremendous depth Piero created through the accuracy of his perspective and the complex mathematical and sym-bolic relationships forming the tile pattern of the floor. The very com-plexity of the picture and obscurity of the subject would have appealed to his patron.

This ability to place his figures in a rational picture space and in a harmonious relationship to one another is exemplified in his great fresco cycle, *The Finding of the True Cross* (1452-66) in Arezzo. Most of the story was taken from the thirteenth-century compendium, the *Golden Legend*, with some additions by Piero, such as the right half of Fig. 24, *The Queen of Sheba Received by Solomon*. This subject also appears in Ghiberti's second Baptistery doors. In Piero's work it sym-bolized the hoped-for reunification of the Roman and Eastern Churches in alliance against the Turks, who had conquered Constantinople in 1453. The scenes are divided centrally, with an Albertian column acting as the vanishing point, the figures given gravity by a low viewpoint, and simplified in shape to convey their bulk. With solemnity and emotional restraint, Piero depicted the miraculous legend with contemporary yet timeless relevance. Called to Rome in 1458, Piero probably met Antonello da Messina and saw Spanish and Netherlandish paintings. On his return to Arezzo he painted the *Battle between Constantine and Maxentius*, which is pervaded by an even greater sense of light and colour. In *Constantine's Dream* (a portrait of the former Eastern Emperor, John VIII Palaeologus), his sensitivity to atmosphere enabled him to create a night scene lit only

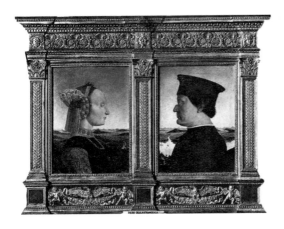

Fig. 9
Piero della Francesca
Portraits of Count
Federigo da
Montefeltro, Count
of Urbino, and his
wife, Battista Sforza
c.1465. Each panel 47 x 33
cm. Florence, Uffizi

by an angel. The dramatic possibilities of directional lighting were further explored in his diptych portrait of Federigo da Montefeltro and Battista Sforza (Fig. 9). As always, Federigo is shown facing left because of damage to his right eye, and although in profile the heads project a great sense of volume, dominating the continuous landscape which links them. The common light source throws Federigo's face into shadow.

Andrea Mantegna (c.1430-1506) spent his youth in Padua where he was influenced by Donatello's works. Although he did not visit Rome until the 1480s, Mantegna was immersed in a romantic vision of antiquity, and whereas Donatello used classical forms as a basis for his art, for Mantegna they were to be transcribed, not adapted. Vasari recorded Mantegna's master Squarcione criticizing the stoniness of the figures, and that Mantegna 'held the opinion that the statues of antiquity were more perfect and composed of more beautiful elements than anything in living nature'. This obsession with classical *minutiæ*, combined with a highly refined style and grasp of perspective, can be seen in the antique world he created, aged seventeen, in his frescoes of the *Lives of Saint James and Saint Christopher* (severely damaged in World War II) in the Ovetari Chapel of the Eremitani (Fig. 10). Despite his passion for the antique much of his symbolism is deeply Christian; his *Saint Sebastian* depicts the triumph of the martyred Roman over a crumbling pagan world.

In 1460 Mantegna was summoned by Marquis Lodovico Gonzaga to Mantua where he spent the rest of his life as court artist. There, in the Camera degli Sposi, he portrayed the Gonzaga family with delightful informality. The charming scene in which the Marquis greeted the return of Cardinal Francesco, in a ravishing landscape peppered with classical buildings, is really a Gonzaga dynastic portrait (Plate 25). The ceiling of the room was decorated with Roman emperors and the centre pierced with an *oculus* or window, painted *di sotto in su* (the first example of illusionistic painting intended to be seen from below), showing ladies playing with putti around a balustrade and a plant pot apparently perched perilously on the edge. The private nature of these apartments delayed general awareness of their decoration, which was later to have an enormous influence on Baroque ceilings. Mantegna experimented with a new medium, copper engraving, which was well suited to his hard linear style and thus his images were disseminated throughout Europe.

The first two Medici rulers of Florence were more reticent in their patronage than their contemporaries in Mantua and Urbino. Cosimo (1389-1464) built churches and encouraged learning, but his caution in politics was reflected in his traditionalist choice of Benozzo Gozzoli for the fresco in the Medici Palace Chapel (Plate 6). His son Piero's career was brief, although he founded the Medici collection of antiquities, where Lorenzo was later to encourage the young Michelangelo to study. Under Lorenzo (1449-92), the arts flourished and the Platonic Academy was established. Lorenzo was, however, criticized for entertaining the people with festivals to divert them from politics. The bloody events of the Pazzi conspiracy in 1478 undermined the humanist atmosphere created by the Medici. However, the treacherous conspiracy, backed by Sixtus IV, was avenged by the Florentines themselves. After a reconciliation with the Pope the major Florentine artists, Botticelli, Domenico Ghirlandaio (1449-94), Luca Signorelli (c.1444/50-1523) and Perugino (c.1445/50-1523), were sent to Rome in 1481 to paint frescoes in the new Sistine Chapel. Lorenzo's son, Giovanni, would be the most powerful Medici patron as Pope Leo X.

Fig. 10
Andrea Mantegna
Saint James Led to
Martyrdom
c.1459. Fresco. Padua,
Eremitani Chapel

Fig. 11
Antonio and Piero
Pollaiuolo
Hercules and Antaeus
Bronze, height 45 cm.
Florence, Bargello

Florentine art was dominated by several large workshops combining many skills. The Pollaiuolo brothers were goldsmiths and painters, whose work was characterized by an interest in the scientific observation of landscape, musculature and violent action. Much of their production was of bronzes, mainly pagan subjects (Fig. 11) which were becoming widely collected. The most famous pupil of the sculptor, Andrea del Verrocchio (1435-88) was Leonardo da Vinci (1452-1519), who painted the angel and landscape in Verrocchio's *Baptism of Christ*. The studio of Domenico Ghirlandaio was patronized by merchants, and the religious subjects of his pictures are often lost beneath their portraits. He was, however, a brilliant exponent of fresco painting, which he taught Michelangelo.

The crisp metallic line of Sandro Botticelli originated in his training as a goldsmith and as a pupil of Lippi. Through his master, Botticelli was adopted by the Medici. He was introduced by Lorenzo to Politian, a philologist and poet, who provided the neo-Platonic themes which enriched Botticelli's work from the late 1470s. The Platonic Academy studied the teachings of Plato in the light of Christianity, which they saw as growing out of pagan antiquity. This Christian-Classical synthesis was portrayed with a lyrical sense of beauty by Botticelli. *The Birth of Venus* (Plate 26) and *Primavera* (Fig. 30), commissioned for a cousin of Lorenzo de'Medici, appear straightforward but are in fact elaborate neo-Platonic interpretations of the Venus myth. Like many others, Botticelli was deeply affected by the apocalyptic sermons of the charismatic Dominican, Savonarola, who preached reform of the Church, foretelling disasters and attacking materialism, and encouraged his followers to destroy books and works of art on 'bonfires of the vanities'.

Although the Medici were to dominate Florence in the sixteenth century as much as the fifteenth, they were exiled twice. After Lorenzo's death a republic of modest aristocrats was formed, inspired by Savonarola and advised by Niccolò Machiavelli. The new era was reflected in the political character of the Republic's commissions – Michelangelo's *David*, and his and Leonardo's *Battles* in the Palazzo Vecchio. But the Republic was weak; its brief moment of piety ended with Savonarola's death at the stake, and its downfall came in 1512 when attacking Spanish forces insisted on the reinstatement of the Medici. Their power was confirmed by the election of two Medici Popes, Leo X (1513-21) and Clement VII (1523-34).

A calm figure in the midst of all this turmoil was Perugino (active c.1472-1523), the Umbrian-born artist whose simplification of forms derived from Piero. Unlike the frenetic works of late *quattrocento*

Fig. 12
Pietro Perugino
The Charge to
Saint Peter
1481. Fresco. Vatican,
Sistine Chapel

Florentine artists, his compositions were lucid and harmonious, his idealized figures classical and placid, though somewhat vapid. He worked in Rome on the Sistine Chapel, where *The Charge to Saint Peter* is exceptional for its clarity (Fig. 12). Through the work of his pupil, Raphael (1483-1520), Perugino's restraint was to become a feature of the High Renaissance.

In northern Italy the very different preoccupations of Giovanni Bellini were to form the essence of Venetian art. According to Vasari, Bellini was ninety when he died in 1516, although a birthdate of 1432-33 seems more plausible. His formative influences were his father, Gentile, the Byzantine art of Venice and Mantegna. Comparison of their paintings of *The Agony in the Garden* (Plates 16 and 17) exposes both Mantegna's influence and the novelty of Bellini's lyrical light bathing the landscape.

The arrival in Venice in 1475 of a Sicilian artist proved a turning point for Bellini and Venetian art. Antonello da Messina (active c.1445-79) had worked for Alfonso of Naples and knew his collection of Flemish paintings. He may even have visited Flanders, for he introduced northern skills in oil-painting into Venice (Plate 13). With Piero and Bellini, Antonello developed the idea (from Masaccio's *Trinity*) of the extension of real space into the composition, and the inclusion of the spectator in its world. In a series of major altarpieces, Bellini studied these illusions suggesting infinite depth, explored human relationships and above all exploited oil paint to create atmosphere. His legacy to his pupils Giorgione and Titian was his understanding of the emotional possibilities of light together with the penetrating insight he and Antonello achieved in their portraits (Plates 22 and 27). His were the last altarpieces to portray a 'human' Divinity; the High Renaissance was to emphasize the awesome inaccessibility of God.

In each of the four main periods of Leonardo's career his achievements were unparalleled. His working life began in the studio of Verrocchio, where he was enrolled in the painters guild in 1472. He castigated artists who were content merely to imitate the ancients, believing the need to study nature – his angels' wings were drawn from those of birds. Leonardo, more practical than philosophical, left the rarified atmosphere of neo-Platonic Florence for service under the brutal Ludovico '*il Moro*' Sforza of Milan. The demands of his Milanese patron, ranging from irrigation schemes and war engines to central heating, appealed to his ingenuity. His notebooks annotated in left-handed mirror writing are a testament to that inventiveness and curiosity. There he began his *Virgin of the Rocks* (Plate 21). His *Last Supper* (Fig. 13) in Santa Maria delle Grazie has a psychological

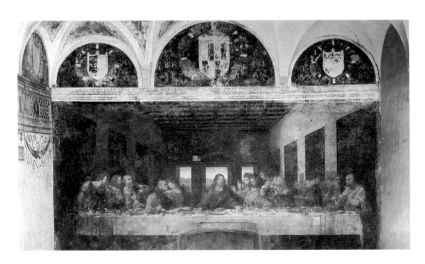

Fig. 13
Leonardo da Vinci
The Last Supper
c. 1497. Oil on plaster.
Milan, Santa Maria
della Grazie

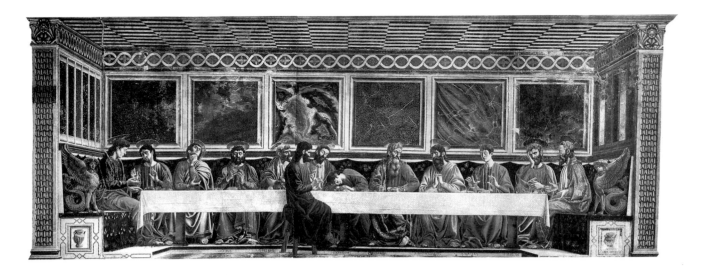

Fig. 14
Andrea del Castagno
The Last Supper
c. 1448. Fresco,
470 x 975 cm. Florence,
Sant'Apollonia

Fig. 15
Peter Paul Rubens
after Leonardo
da Vinci
The Fight for the
Standard (from 'The
Battle of Anghiari')
1612-15. Black chalk,
pen and ink, washed,
heightened with grey
and white body-colour.
45.2 x 63.7 mm. Paris,
Musée du Louvre

Fig. 16
Aristotile de Sangallo
after Michelangelo's
lost cartoon for
The Battle of Cascina
1542. Grisaille, 76.2 x 132
cm. Holkham Hall,
The Earl of Leicester

tension missing from all earlier depictions (Fig. 14). Leonardo chose the moment of highest emotional drama, when Christ has announced that one of the disciples shall betray Him. Their gestures of horror and disbelief express the impact of his words. Judas is not isolated from the other disciples, but is identified with shadow. The painting is largely invisible thanks to Leonardo's experimental technique and the attacks of generations of restorers. When Milan's Sforza dynasty fell to the French invaders in 1499, Leonardo fled via Mantua to Venice, and returned to Florence in 1500, aged nearly 50. He spent 1502-3 working for the evil adventurer Cesare Borgia as a military engineer, and was then commissioned with Michelangelo by the Florentine Republic to decorate the new Council Chamber in the Palazzo Vecchio with representations of Florentine victories. Leonardo's *Battle of Anghiari* distilled the violence and energy of war, 'the most bestial of follies', while Michelangelo's pendant, showing a group of nude soldiers surprised while bathing at the *Battle of Cascina*, was for Vasari a 'revelation of the perfection that the art of painting could reach'. Julius II interrupted work by summoning Michelangelo to Rome. Leonardo's painting perished and Michelangelo's cartoon was eventually destroyed; only their drawings and copies by other artists survive (Figs. 15 and 16).

Leonardo returned to Milan as court painter to Francis I of France, where he concentrated on his scientific studies. Under Medici patronage he went to Rome in 1513, but achieved little in the milieu dominated by Michelangelo and Raphael. He died in 1519 in the château he was given by Francis I.

His unpublished notebooks, the product of a lifetime's curiosity, were left to Francesco Melzi and were unknown until Melzi's death in 1570. Leonardo was a pioneer in his studies of the mechanisms of nature, understanding that every detail of an organism contributes to the functioning of the whole. His anticipation of the invention of tanks and helicopters and his grasp of the solar system is legendary, but his constant annotation *Dimmi se mai fu fatto alcuna cosa?* (Tell me if anything was ever done?) betrays his disappointment that so many of his projects could come to nothing.

Michelangelo Buonarotti (1475-1564) always regarded himself as a sculptor, but under pressure from his patrons excelled in the fields of architecture and painting, and privately as a poet. When young he lived in the neo-Platonic atmosphere of the Medici household and began sculpting in marble. He fled to Venice after the Medici's expul-

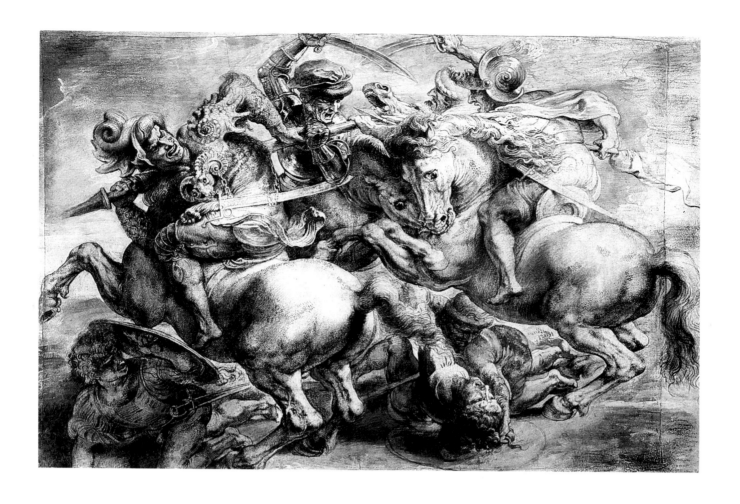

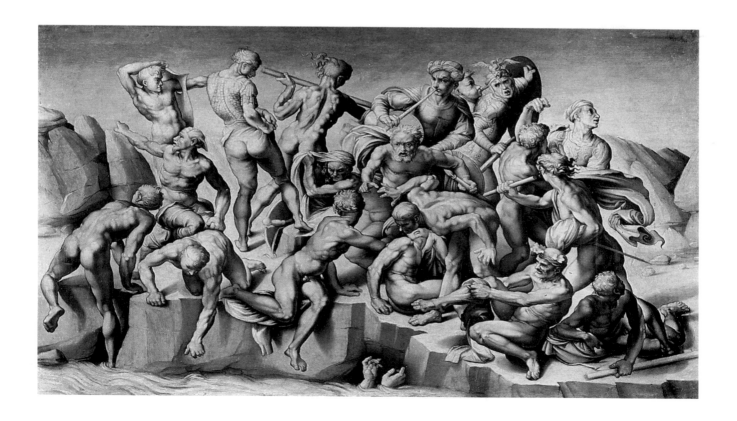

Fig. 17
Michelangelo
Pietà
1498-99. Marble, height
175.3 cm. Rome, St
Peter's

sion and arrived in Rome in 1496, where a French cardinal commissioned a *Pietà* (Fig. 17). Michelangelo transformed this northern genre, rarely treated in Italy, into a classical group, and resolved the problem of placing the dead weight of a man over the knees of a woman by slightly altering their scale. Our Lady's gesture indicates her grief and acceptance of His sacrifice. The moving tenderness of the group is unusual in Michelangelo's work until his late sonnets and drawings of the Crucifixion for Vittoria Colonna. The *contrapposto* of Christ was extremely influential, and was quoted by Raphael in his *Entombment* and both Jacopo Pontormo (1494-1556) and Rosso Fiorentino (1495-1540) in their *Depositions* (Figs. 20 and 35).

Now famous, Michelangelo returned to Florence in 1501. The Signoria wanted a symbol of the strength of the Republic, and for them Michelangelo sculpted the *David*, an ideal figure of perfect anatomy placed outside the Palazzo Vecchio. A technical triumph, the figure was carved from a shallow block already ruined and abandoned by other sculptors. The *David* typifies the depth of meaning inherent in Renaissance works of art. Connotations of civic fortitude such as the Florentines had displayed were reflected in David, a fighter for freedom against superior odds who saved his people and became king, and who was in turn an Old Testament prefiguration of Christ's triumph in the New Testament. He was also paralleled in classical mythology by the heroic virtue of Hercules.

Pope Julius II's disruption of Michelangelo's work on his grandiose tomb was to be the 'tragedy' of Michelangelo's life, for he was never able to complete it. Julius' energy was prodigious – he charged the architect Bramante to replace the old basilica of Saint Peter's with a centrally planned church (though no progress was really made until Michelangelo assumed direction of the project in 1547), and Raphael, Bramante's virtually unknown compatriot, to decorate new apartments (rather than use those of his despised Borgia predecessor, Alexander VI). Michelangelo was diverted from work on the tomb to paint the Sistine Chapel ceiling in 1508.

Meanwhile Raphael, who had probably studied under Perugino and adopted his placid and spacious style, had come to Rome. Although not imitative, he was quick to absorb the achievements of the Florentine *Battles*, Leonardo's soft modelling and pyramidal composition and in Rome any new archaeological discoveries. When he began to paint the new suite of Papal offices, Raphael had little experience of fresco or handling large-scale figure groups, but his achievements were astonishing. The frescoes of the Stanza della Segnatura (1509-11), a library, represent divinely inspired human intellect: Poetry, Philosophy (Plate 31), Jurisprudence and Theology. The ceiling was decorated, like the Roman ceilings of Hadrian's Villa, with abstract personifications. In the subordination of detail to the total effect the Stanza is the epitome of High Renaissance order and calm.

Michelangelo was dismissive of Raphael – ' all he knows he learnt from me' – and indeed his influence can be seen in the evolution of Raphael's work from the early Stanza della Segnatura to the later Stanze painted for Leo X. By the time Raphael arrived in Rome, Michelangelo had reluctantly begun work on the Sistine ceiling (Plate 37). The first half was unveiled in August 1511, the second a year later, and it astonished all who saw it. The scheme and execution of this enormous undertaking were entirely Michelangelo's own. The *Last Judgment* (1536-41) on the altar wall, painted for the dying Clement VII and Paul III, shows Michelangelo in the darker mood that pervaded Rome after the Sack.

In the ceiling Michelangelo worked out many of his ideas for the

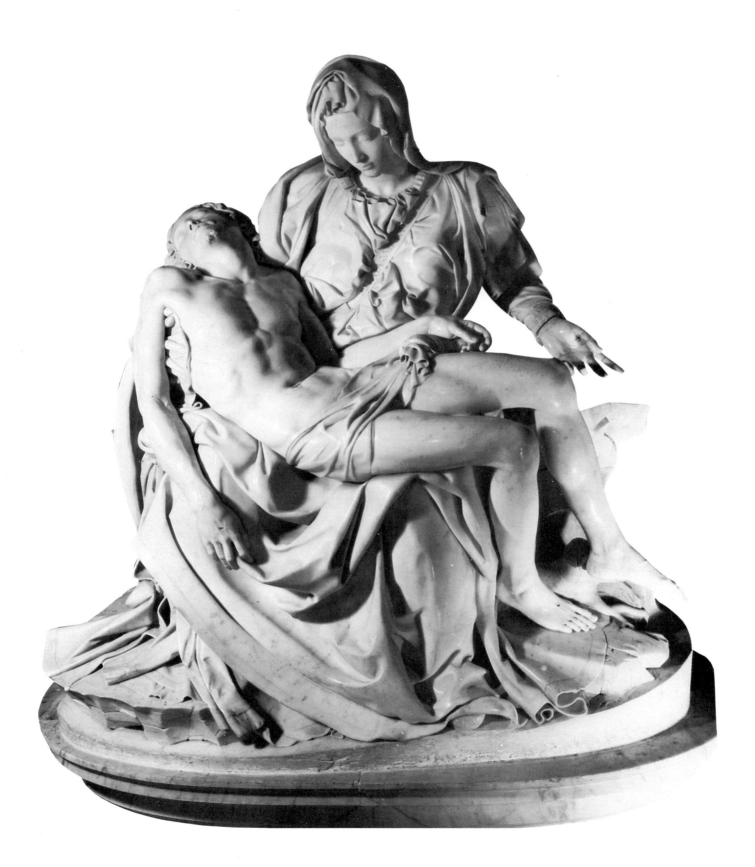

19

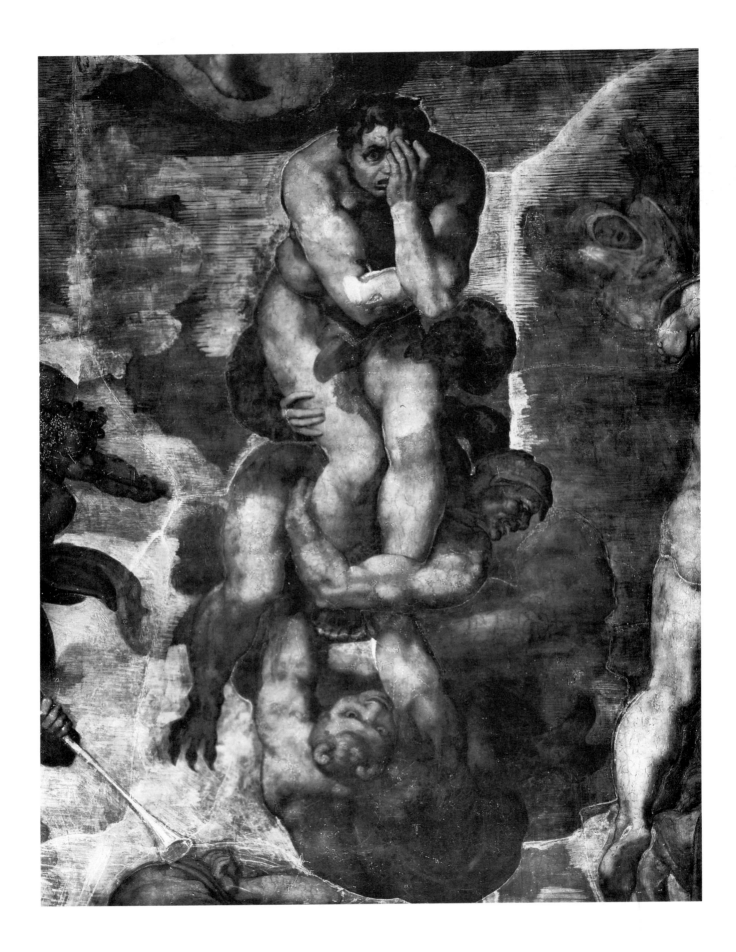

tomb and the *Battle of Cascina*. Bold in scale, it shows his preoccupation with the classical nude and its ability to express Christian and noble sentiments. Vasari, who believed Michelangelo had been chosen by God, thought 'there is no other work to compare with this for excellence, nor could there be; and it is scarcely possible even to imitate what Michelangelo accomplished.' Nevertheless, artists concentrated on imitating the heroic nudes and particularly the contortions of the *ignudi*, who represent the perfection of the human form.

Many of Michelangelo's masterpieces were still to come after 1520, the year of Raphael's death – the Medici Chapel, the *Last Judgment*, the Rondanini *Pietà* and his work on Saint Peter's. Leo X employed Michelangelo in Florence, first on the family church of San Lorenzo, and then for Cardinal Giulio, later Clement VII, on their mausoleum, the New Sacristy. The effigies of Giulio and Lorenzo de'Medici portray their active and contemplative states of mind – while the figures of *Day*, *Night*, *Dawn* and *Dusk* on the tombs represent earthly time.

Throughout Michelangelo's work, his deeply reflective piety is apparent. It was expressed with awesome power in his *Last Judgment*, which, charged with pessimism and violence, reflected the change that had come over Rome. The Council of Trent called to counter the attacks of the Protestant Reformation issued rulings on decorum and Michelangelo's 'sacrilegious' nudes provoked outrage. Draperies for his figures were later provided by Daniele de Volterra.

Reputed to have been ninety-nine years old at his death in 1576, Titian was probably born in the mid-1480s. From the death of Bellini in 1516, he dominated Venetian art. A pupil of the Bellini brothers, Titian was nevertheless more influenced by the innovative work of Giorgione, with whom he worked on the now invisible exterior frescoes of the Fondaco dei Tedeschi (1508). Titian completed some of Giorgione's works after his death, resulting in disputed attributions. In Venice's salty atmosphere, frescoes deteriorated and the medium of oil and canvas (replacing panel as a support) was developed by Giorgione and Titian whose brushwork exploited the textural surface of the canvas. This painterliness was associated with a compositional use of colour. The luminosity of Bellini's works was achieved with translucent oil-glazes over a light base, but Giorgione, and subsequently Titian, painted over red, using opaque colour and broken brushwork to depict light. Most of Giorgione's output was in the new secular genre of romantic, apparently mysterious subjects, which demanded the involvement of the spectator in the manner of Leonardo.

Whereas Michelangelo was an architect, as well as a sculptor and painter, the Venetian state limited its artists to one discipline. Titian revolutionized all the genres he worked in: altarpieces, portraits and *poesie* (mythological paintings). The Venetian High Renaissance begins with the *Assumption of the Virgin* (1516-18) for the Frari. The earthbound apostles, cast into shadow by the ascending Virgin are linked to the divine by a silhouetted gesture. In the Pesaro altarpiece, also for the Frari (Fig. 19), Titian substituted a dynamic diagonal for the conventional frontal composition. Our Lady and Christ are placed off-centre, and the narrative flows in a sinuous curve from the kneeling Pesaro family, via Saint Peter and Our Lady, who is linked by Saint Francis to the family, and to the spectator at whom the youngest member looks. The two monumental columns stabilize the right-hand group and the *contrapposto* arrangement of Saint Peter and the bearer of the Pesaro-Borgia standard with his Turkish prisoner. (Pesaro commanded the Papal and Venetian fleets at the Battle of Santa Maura in

Fig. 18
Michelangelo
Figure from 'The
Last Judgment'
1536-41. Fresco. Vatican,
Sistine Chapel

Fig. 19
Titian
The Madonna of the
Pesaro Family
1519-26. Oil on canvas,
47.8 x 26.8 cm. Venice,
Santa Maria dei Frari

1502 defeating the Turks, the altarpiece was commissioned as a thanksgiving.) This dynamism was continued in his *Bacchanals* for Alfonso I d'Este's *Camerino d'Alabastro* (Plate 30).

Titian was a portraitist of international renown, his sitters including popes, emperors and kings. He exploited the German full-length pose, rarely used in Italy, and became Emperor Charles V's favourite Imperial painter. Always penetrating in his understanding and depiction of character, it was in his group portraits that he established the greatest interplay between his sitters. In the sinister Farnese group (Plate 44), the bodies are as expressive as the faces. Charles V abdicated in 1555 and his successor Philip II of Spain became Titian's principal patron, allowing him to paint virtually what he chose.

By 1530 the brief period of clarity and order marked by the High Renaissance in Rome was over. Michelangelo was in Florence and Raphael's studio scattered following his death – Giulio Romano to Mantua in 1524, and Polidoro da Caravaggio to Naples in 1527. Many artists fled Rome's plague of 1522, or were idle under the rule of the philistine Pope Adrian VI (1522-23); others either escaped or were trapped in Rome's disastrous Sack of 1527.

In Florence, the Medici, whose power had seemed so secure, fled from a popular uprising days after the Sack of Rome. Michelangelo again supported the new republican government and abandoned his Medici commissions. A bitter siege ended with capitulation in 1530 and the restoration of the Medici. From 1537 the young Cosimo I ruled Florence, becoming Grand Duke in 1569 and surpassing his predecessors in the scale of his patronage.

These turbulent years saw the growth of 'Mannerism', beginning in Florence as early as 1515, although attempts to link this extreme style to political instability should be avoided – many artists, especially Venetians, were not similarly affected. Events in Rome disseminated rather than created Mannerism. It was not so much a reaction to the 'classicism' of the High Renaissance as an elaboration of elements inherent in the late work of Raphael and Michelangelo. Mannerism derives from the Italian *Maniera* (inadequately rendered as 'style'), and was included by Vasari as one of the five qualities which made sixteenth-century art superior to previous forms. The style is highly sophisticated, elegant and artificial, the compositions and space obscure, with *contrapposto* figures and expressive, often 'shot' colour.

Rosso Fiorentino and Jacopo Pontormo created Florentine Mannerism out of the classicism of Fra Bartolommeo and their master Andrea del Sarto. Their work appears anti-classical with the abandonment of traditional perspective and formal composition, as in Pontormo's *Joseph in Egypt* (Plate 38) and the intense emotion in Rosso's *Deposition* (Fig. 20). Rosso's Christ owes much to Michelangelo's *Pietà*, but the violent grief of the figures is expressed by distortions of the bodies and faces and extended to the illumination of the eclipse by lightning. Rosso's work in Rome (1523-7) reflected the influences of Mannerists there and his ill-treatment during the Sack. He later took Mannerism to the court at Fontainebleau where he was joined by Primaticcio, and together they influenced the course of French painting.

Although it appears to reject classicism, Pontormo's *Deposition* in Santa Felicità (Fig. 35) quotes Raphael's *Entombment* and their common source: antique reliefs of the *Death of Meleager*. The figures are of an idealized beauty, covered in the thinnest draperies. The lurid colours illuminate the chapel with an unearthly light, and contribute to the strangeness of the unreal space through which the body of Christ is twisting out and away from His swooning mother.

Fig. 20
Rosso Fiorentino
The Deposition
1521. Oil on panel,
340 x 200 cm. Volterra,
Pinacoteca Communale

The career of Parmigianino (1503-40) was initially shaped by Antonio Correggio's work in Parma. Correggio (1494-1534), in his great illusionistic ceiling decorations (evolved from Mantegna's), his soft modelling, expression and revolutionary illumination, prefigured the Baroque. Parmigianino was in Rome by late 1523, where he strove to imitate the art of Raphael. There he painted his graceful works with their strange dissonant scale (Plate 39). He was captured during the Sack of Rome and, according to Vasari (as ever unsympathetic to eccentricity), declined from former elegance into an unkempt savage obsessed with alchemy.

Venice remained largely aloof from Mannerism, although in some of Titian's works Mannerist forms appear and in the 1540s his subject-matter became darker and more violent. Only Tintoretto (1518-94) displays any real Mannerist tendency; although he was influenced by Andrea Schiavone who had introduced the sinuous idiom of Parmigianino to Venice, Tintoretto's works were often elegant but lacked the polish of the Mannerists.

Titian is supposed to have expelled Tintoretto from his studio after only one day. Although Tintoretto based his art on the drawing of Michelangelo and the colour of Titian, it is like neither. He was aware of Michelangelo through engravings and models, copying the figures from bizarre angles. He grew up in an atmosphere of Counter-Reformation, and his work is mystical, the antithesis of Titian's. Tintoretto was intensely religious and often worked for nothing. His bravura compositions, like his colour, were expressive rather than realistic; characterized by dramatic foreshortening and viewpoints, flickering unnatural light, violent action and contorted figures, they were explosive and prove his link with Mannerism. His greatest work was the decoration of the building of the Scuola di San Rocco (1565-88).

Paolo Veronese (c.1528-88) worked in Venice from 1553. His *oeuvre* consists largely of theatrical religious or mythological scenes in magnificent architectural settings. He took a hedonistic delight in depicting rich costumes and the textures of glass, fur and jewels. His knowledge of the antique is revealed in his series of Loves of the Gods (Plate 48). Veronese's *Last Supper*, commissioned for the refectory of Santi Giovanni e Paolo, brought him before the Inquisition in 1573. Asked to explain the presence of 'dogs, buffoons, drunken Germans, dwarfs and other such absurdities' in the work, he replied that he had used 'the same licence as poets and madmen'. Throughout the interrogation Veronese defended artistic licence against philistinism, and escaped being condemned as a heretic.

It is significant that out of the apparently reactionary fervour of the Council of Trent should emerge an art of such energy and spiritual confidence as the Baroque. Although its interpretations were radically different, the Baroque was based on the innovations in light, space and dynamism which characterized the art of the Renaissance.

Select Bibliography

SOURCES

Leon Battista Alberti, *On Painting and Sculpture*, ed. and trans. C. Grayson, London, 1972

Cennino Cennini, *The Craftsman's Handbook*, trans. D. V. Thompson Jr, New Haven, 1933

Leonardo da Vinci, *The Literary Works of Leonardo da Vinci*, ed. and trans. J. P. Richter, commentary C. Pedretti, 2 vols, Oxford and Berkeley, 1977

Giorgio Vasari, *The Lives of the Artists*, 2 vols, trans. G. Bull, London, 1965

GENERAL WORKS

Ames-Lewis, F., *Drawing in Early Renaissance Italy*, New Haven and London, 1981

Baxandall, M., *Painting and experience in fifteenth-century Italy*, London, 1981

Bober, P. Pray, and Rubinstein, R., *Renaissance Artists and Antique Sculpture*, Oxford, 1986

Borsook, E., *The Mural Painters of Tuscany*, second edition, Oxford, 1981

Burckhardt, J., *The Civilization of the Renaissance in Italy*, trans. S.G.C Middlemore, London, 1990

Chastel, A., *The Art of the Italian Renaissance*, trans. P. and L. Murray, London, 1983

Dunkerton, J., Foister, S., Gordon, D., and Penny, N., *Giotto to Dürer: Early Renaissance Painting in Italy*, London, 1991

Gage, J., *Life in Italy at the Time of the Medici*, 1968

Gilbert, C., *Italian Art 1400-1500*, Englewood Cliffs, 1980

Hale, J. R., ed., *A concise history of the Italian Renaissance*, London, 1981

Holt, E., *A documentary history of art, vol.1: The Middle Ages and the Renaissance*, Princeton, 1981

Levey, M., *Early Renaissance*, London, 1967

—, *High Renaissance*, London, 1975

Murray, L., *The High Renaissance and Mannerism: Italy, the North and Spain 1500-1600*, London, 1967

Murray, P. and L., *The Art of the Renaissance*, London, 1963

Pope-Hennessy, J., *Italian Renaissance Sculpture*, second edition, London, 1972

—, *The Portrait in the Renaissance*, Oxford, 1967

Shearman, J., *Mannerism*, London, 1967

White, J., *The birth and rebirth of pictorial space*, London, 1957

MONOGRAPHS

Berti, L., *Masaccio*, London, 1967

Christiansen, K., *Gentile da Fabriano*, London, 1982

Clark, K., *Leonardo da Vinci*, revised edition by Martin Kemp, London, 1988

—, *Piero della Francesca*, second edition, London, 1969

Ettlinger, L., *Antonio and Piero Pollaiuolo*, Oxford, 1978

Janson, H. W., *The Sculpture of Donatello*, 2 vols., Princeton, 1957

Joannides, P., *Masaccio and Masolino, a complete catalogue*, London, 1993

Jones, R. and Penny, N., *Raphael*, London, 1983

Kemp, M., *Leonardo da Vinci: The marvellous works of nature and man*, London, 1981

Krautheimer, R., *Lorenzo Ghiberti*, third edition, Princeton, 1982

Lightbown, R., *Botticelli*, second edition, London, 1990

Marchini, G., *Filippo Lippi*, second edition, Milan, 1979

Pope-Hennessy, J., *Fra Angelico*, second edition, London, 1968

Popham, A. E., *The drawings of Leonardo da Vinci*, London, 1946

Tomasi, L. T., *L'opera completa di Paolo Uccello*, Milan, 1971

EXHIBITIONS

Drawings by Michelangelo, catalogue by J. A. Gear, British Museum, London, 1975

The Genius of Venice 1500-1600, catalogue ed. by J. Martineau and C. Hope, Royal Academy, 1983

List of illustrations

Colour Plates

Text Illustrations

Comparative Figures

21 Masaccio
 The Tribute Money
 c.1425. Fresco. Florence, Brancacci Chapel, Santa
 Maria del Carmine

22 Gentile da Fabriano
 Madonna and Child
 c.1425. Tempera on panel, 96 x 57 cm. Washington,
 National Gallery of Art,
 Samuel H. Kress Collection

23 Fra Filippo Lippi
 The Barbadori Altarpiece
 Madonna and Child with Angels, Saint
 Frediano and Saint Augustine (central
 panel)
 c.1437. Oil on panel, 208 x 244 cm. Paris,
 Musée du Louvre

24 Piero della Francesca
 The Queen of Sheba Adoring the
 Holy Wood/The Queen of Sheba
 Received by Solomon
 c.1459. Fresco. Arezzo, San Francesco

25 Domenico Ghirlandaio
 Detail of portrait heads
 c.1490. Fresco. Florence, Santa Maria Novella

26 Sassetta
 The Dream of Saint Francis
 c.1437-44. Egg tempera on panel, 87 x 52.5 cm.
 London, National Gallery

27 Piero di Cosimo
 Old and Young Satyrs in a Tree (Detail
 from 'The Discovery of Honey')
 c.1505-7. Tempera on panel, 80 x 128.5 cm.
 Massachusetts, Worcester Art Museum

28 Leonardo da Vinci
 Study of Flowering Plants
 c.1506. Pen and ink over red chalk, 19.8 x 16 cm.
 Windsor, Royal Collection (reproduced by gracious
 permission of Her Majesty the Queen)

29 Sandro Botticelli
 Detail from 'The Adoration of the Magi'
 c.1475-77. Tempera on panel, 111 x 134 cm.
 Florence, Uffizi

30 Sandro Botticelli
 Primavera
 1478. Tempera on canvas, 203 x 313.6 cm.
 Florence, Uffizi

31 Titian
 Bacchus and Ariadne
 1520-22. Oil on canvas, 175.2 x 190.5 cm. London,
 National Gallery

32 Raphael
 Cartoon for 'The School of Athens'
 1510. Charcoal, black chalk, white
 heightening on many sheets of paper,
 280 x 800 cm. Milan, Ambrosiana

33 Raphael
 The Entombment
 1507. Oil on panel, 184 x 176 cm. Rome,
 Borghese Gallery

34 Michelangelo
 Studies for the Libyan Sibyl
 c.1510. Black chalk, 28.9 x 21.3 cm. New York,
 Metropolitan Museum of Art (Purchase, 1924,
 The Joseph Pulitzer Bequest)

35 Jacopo Pontormo
 The Deposition
 1526-28. Oil on panel, 313 x 192 cm. Florence,
 Santa Felicità

36 Raphael
 Fire in the Borgo
 1514. Fresco. Vatican

MASACCIO (1401-c.28)
The Trinity

1427. Fresco. Florence, Santa Maria Novella

In his *Trinity* Masaccio creates the illusion of a chapel receding back into the church wall. Our Lady invites the spectator to observe the divine mystery taking place in the presence of the kneeling donors, and, by extension, us. By making the divine figures conform to one system of perspective and the donors and architecture to another, Masaccio distinguishes between spiritual rather than actual presence. The design of the classical chapel with its barrel-vaulted ceiling may have been devised by Brunelleschi and was particularly admired by Vasari.

The early use of an incised grid, over which Masaccio painted the head of Our Lady, throws some light on the use of preparatory drawings for fresco. Although none by Masaccio survive, he must have worked from squared-up drawings to transfer his complex foreshortenings on to the wall. The underdrawing or *sinopia* (red-earth pigment) would be hidden by the day's application of plaster to which the fresco would be applied. Michelangelo was later to use full-scale cartoons to transfer his designs, often reusing them in reverse.

In *The Tribute Money* (Fig. 21) Masaccio employs traditional continuous representation to portray the miracle. The composition is articulated around Christ's head, the vanishing point for the perspective, and the spectator's attention is thus controlled and directed to witness the miracle. The use of light as though from a real window in the chapel had been employed by Giotto, but with little success. Masaccio exploited the unifying light to create an harmonious space, with figures defined by tone and colour.

In order not to give offence, Christ paid the annual half-shekel tax for the maintenance of the Temple in Jerusalem, although His followers were, He said, exempt as subjects of the Kingdom of Heaven. He told Peter to cast his line into the lake, where he would catch a fish with a shekel in its mouth.

Fig. 21
Masaccio
The Tribute Money
c.1425. Fresco. Florence,
Brancacci Chapel, Santa
Maria del Carmine

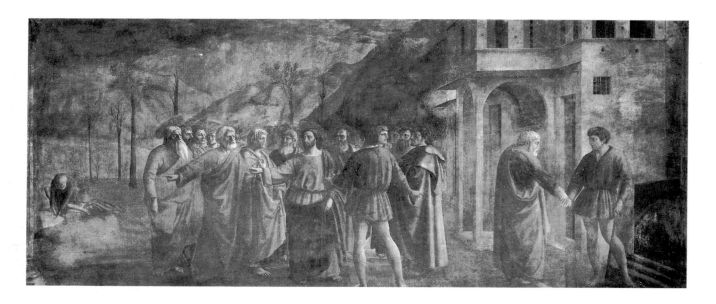

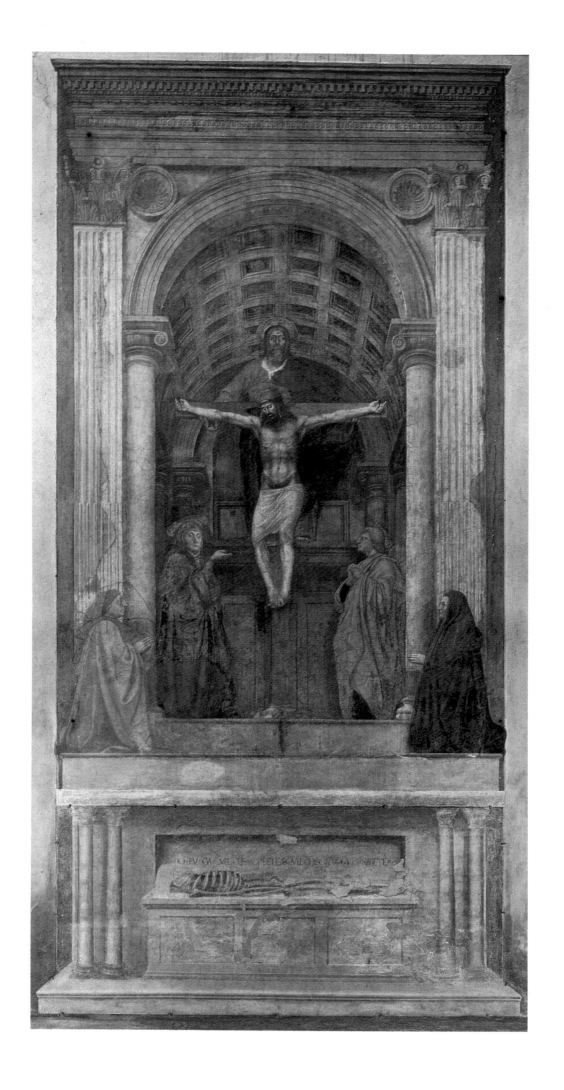

MASACCIO (1401-c.28)
The Virgin and Child Enthroned

1426. Egg tempera on panel, 135.5 x 73 cm. London, National Gallery

Fig. 22
Gentile da Fabriano
Madonna and Child
c.1425. Tempera on panel,
96 x 57 cm. Washington,
National Gallery of Art,
Samuel H. Kress
Collection

This Madonna and Child formed the centre section of a polyptych (a picture on multiple panels) commissioned for the chapel of Saint Julian in the church of Santa Maria del Carmine, Pisa, in 1426. Comparison of Masaccio's painting with Gentile's version (Fig. 22) reveals the differences between the International Gothic style and the new realist style. Gentile's detail is realistically observed but the poses are courtly and the colour used decoratively, the space and lighting are irrational and though diagonal lines suggest recession, the figures do not appear three dimensional. Masaccio's altarpiece shows an early use of single point perspective, the effects of which are particularly noticeable in the depiction of the throne and musical instruments, combined with uniform directional lighting and a low viewpoint to enhance the figures' monumentality. The Christ Child is human and convincing; the grapes He crushes in His fists symbolize the wine of the Eucharist, and thus the blood of the Passion. (The Crucifixion was depicted above this central panel of the altarpiece.) Masaccio retained traditional pictorial elements such as the gold background, here transformed into a blaze of light, and the stamping of Our Lady's halo with the words from the Annunciation, *Ave Gratia Plena*, although Christ's halo is realistically foreshortened in three dimensions, an innovation begun (though somewhat illogically) by Giotto in the previous century. The interest in classical architecture and sculpture that was being revived by Brunelleschi can be seen in the throne, which is constructed with Corinthian columns, and in the step decorated with a motif taken from antique sarcophagi. Vasari noted the charm with which the right-hand angel is 'sounding a lute and inclining his ear very attentively to listen to the music he is making'.

FRA FILIPPO LIPPI (active c.1432-69)
The Madonna and Child

c.1440-45. Tempera on panel, 80 x 51 cm. Washington, National Gallery of Art, Samuel H. Kress Collection

This wistful young Madonna and Child is typical of Lippi's beautiful small altarpieces, which combine on the one hand an ideal beauty (Lippi's Madonnas were supposed to have been modelled on the features of his mistress, the Carmelite novice, Lucrezia Buti), and on the other, the realism he derived from Donatello and Luca della Robbia. Their influence can again be perceived in the two young monks (one of whom is supposedly Lippi himself) looking out from behind the balustrade in the *Barbadori Altarpiece* (Fig. 23).

Lippi always delighted in the depiction of patterns and textures, paying great attention to haloes, gauze, marble, feathers and draperies. In *The Madonna and Child* he combines this linear element with a sculptural solidity, setting the figures in a classical niche. The precise observation of material detail, and of the intimacy with which the gentle young Madonna holds the wriggling Christ, links this picture with depictions of the Holy Family by northern painters. The sources of northern influence on Lippi are not known, nor what works by the Flemish masters were available in Florence at that time; the hugely influential *Portinari Altarpiece* by Hugo van der Goes did not arrive there until 1475.

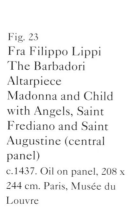

Fig. 23
Fra Filippo Lippi
The Barbadori
Altarpiece
Madonna and Child
with Angels, Saint
Frediano and Saint
Augustine (central
panel)
c.1437. Oil on panel, 208 x
244 cm. Paris, Musée du
Louvre

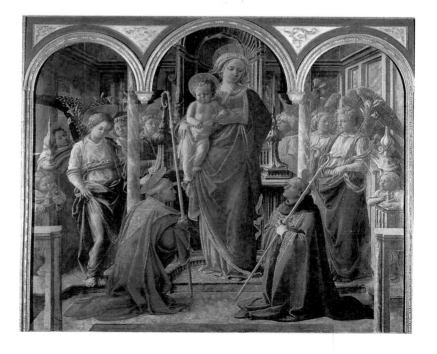

4 GENTILE DA FABRIANO (c.1370 – 1427)
The Adoration of the Magi

1423. Tempera on panel, 300 x 282 cm. Florence, Uffizi

On his arrival in Florence in 1422, Gentile da Fabriano was immediately commissioned by Palla Strozzi to paint *The Adoration of the Magi* for the chapel in the sacristy of Santa Trinità. The work is signed and dated 1423. Gentile left Florence in 1425 and went to Rome via Siena and Orvieto, dying in 1427.

Ever popular as a subject with the Florentines (Plates 6 and 7) the biblical story of the Adoration is combined here with a representation of a procession. The composition is enlivened by the inclusion of birds and monkeys and a wealth of naturalistic detail, from the page undoing his master's spurs in the foreground to the crops planted in the fields of the distant hills. The artists of the International Gothic, of which Gentile was a prime exponent, made great use of detailed drawings, particularly of animals (Fig. 7). However, Gentile's depiction of the figures in sinuous, rather unnatural poses was deliberate; his concern lay not with the portrayal of figures set in realistic space, but with the overall decorative effect. He had been working in Venice with Pisanello on frescoes (now destroyed), and something of the richness and liberal use of gold in Venetian Byzantine decoration is reflected here.

This altarpiece was hugely influential, Lorenzo Monaco basing his depiction of the same subject on it to the extent of using the same three-arched format, while Fra Angelico and Fra Filippo Lippi were to use elements from it in their *Adoration* (Plate 7).

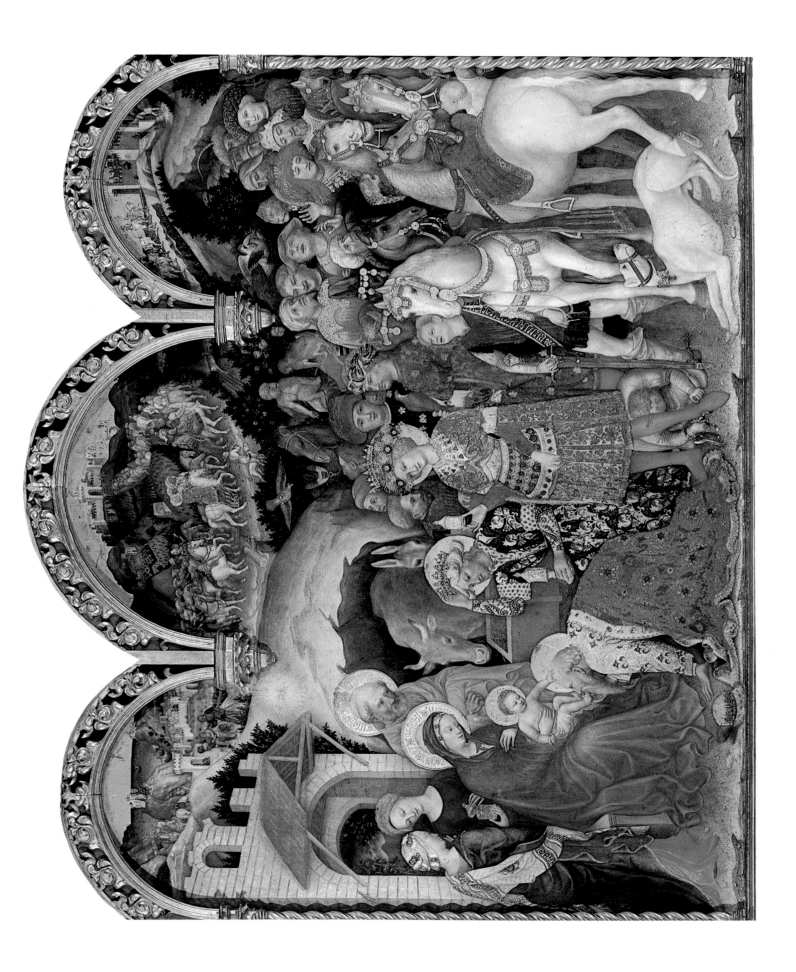

FRA ANGELICO (c.1387/1400-55)
Scenes from the Life of Saint Lawrence

c.1447-49. Fresco. Vatican, Chapel of Nicholas V

Nicholas V (1447-55), born Tommaso Parentucelli, was the 'humanist Pope' who began the great cultural revival and adornment of Rome. He was renowned for his scholarship – 'What was unknown to Parentucelli, lay outside the sphere of human learning' – and, through his friendship with Cosimo de'Medici, summoned, among others, Fra Angelico and Benozzo Gozzoli to Rome as part of his scheme to renew Papal authority through patronage of the arts. His connoisseurship did not preclude him from removing in a single year 2,300 wagon-loads of marble from the Colosseum for building materials, an act which would now be seen as vandalism.

Saint Lawrence was ordained by Pope Sixtus II in the year 257 and was martyred by being roasted on a rack one year later. The left-hand side of the fresco shows the Pope entrusting Lawrence with the treasures of the Church; the Saint is depicted with the features of Nicholas V, and wears a robe covered with the flames of his martyrdom. On the right, framed by the apse of a colonnaded basilica, Lawrence is seen giving alms. When ordered to hand over the treasures to the Imperial authorities, he assembled the poor, saying, 'These are the treasures of the Church.' He is thus the patron saint of the poverty-stricken masses.

Pope Nicholas V intended to declare the year 1450 a jubilee. The Porta Santa of Saint Peter's in Rome was only opened at the beginning of such a Holy Year. This may be the significance of Fra Angelico's depiction of two men breaking down the door on the left.

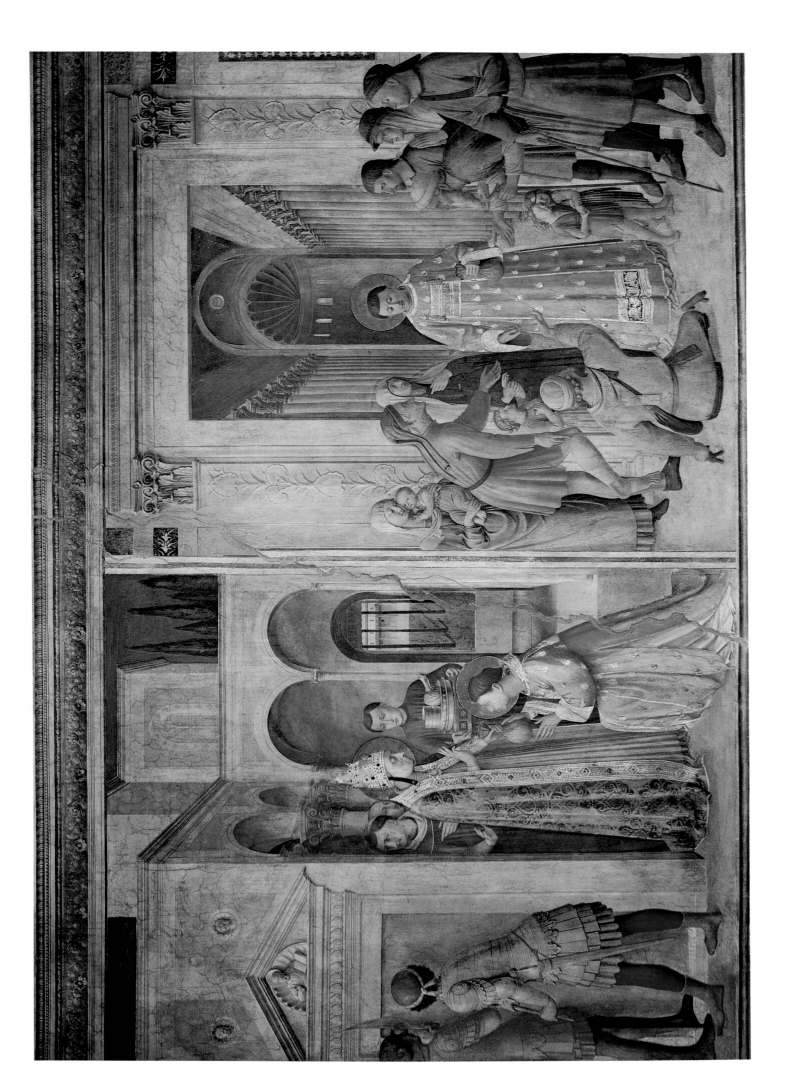

BENOZZO GOZZOLI (1420-97)
The Journey of the Magi

c.1459. Fresco. Florence, Medici Palace, Chapel

In Florence and Venice confraternities or *scuole* of laymen were attached to religious orders and dedicated to charitable works. The confraternities were often associated with a particular cult, such as the flagellants in Venice, or with hospitals for the incurable. In Florence the *Compagnia de'Magi* held splendid processions at Epiphany, with its members dressed as the Magi: in 1454, 200 horsemen followed the procession. The subject was therefore a popular one in Florence, and depictions of the Adoration or of the Journey of the Magi often included portraits recalling such occasions. Here the procession winds through the valley of the River Arno, carpeted with flowers, and strewn with strange trees and fantastic rocks. It is led by Lorenzo *'il Magnifico'* de'Medici; behind him on the left is his grandfather, Cosimo, and on the right his father, Piero (both portraits were painted posthumously). Humanist scholars had revived the classical idea of Fame and with it grew the desire for portraits and medals embodying both an image of the sitter and something of their nature in the form of a motto or device. Here Gozzoli illustrates the near-regal status enjoyed by the Medici in republican Florence.

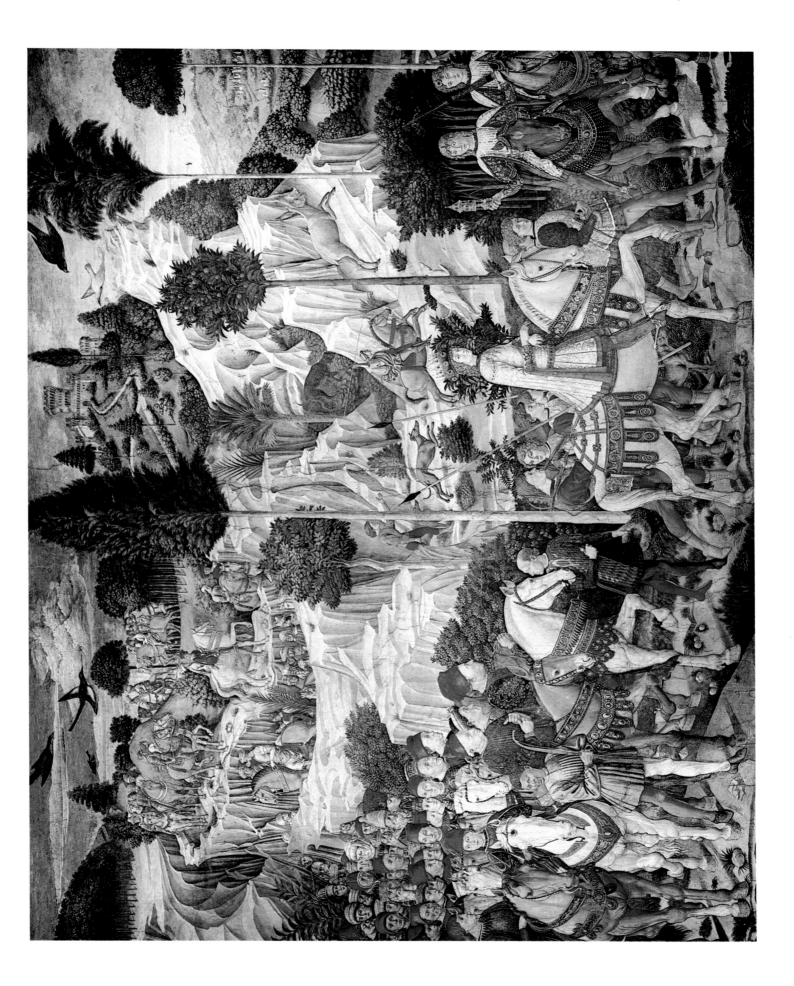

FRA ANGELICO (c.1387/1400-55) and FRA FILIPPO LIPPI (active c.1432-69)
The Adoration of the Magi

c.1430-c.1455. Tempera on panel, 137.4 cm diameter. Washington, National Gallery of Art, Samuel H. Kress Collection

The dating of this *tondo* (a circular picture) is much disputed. It is probably the same painting that hung in Lorenzo de'Medici's bedroom and was recorded there in an inventory made in 1492. The composition is almost certainly by Lippi, who went on to develop the strange arrangement of space in his Pitti *tondo*, but it also involves the work of the slightly older Fra Angelico. Arguably begun as early as the 1430s, the *tondo* may have been abandoned and later completed in the 1450s. *Pentimenti* (corrections made visible through thinned layers of paint) and X-rays have revealed that parts of the composition were changed.

Certain elements are clearly attributable to Fra Angelico: the city walls (which are depicted in the same way as those in his *Deposition*, Florence, Museo di San Marco), the Virgin and Child, the flowered grass (a reference to paradise), the figures and animals in the stable and those walking up the hill. Lippi's treatment of architectural ruins is quite different. He was responsible for the figures of Saint Joseph, the shepherd behind him, the Magi, the semi-naked youths and the figures in the procession. Many of the poses, for example the man in red, his face and hands raised in awe, are close to Gentile's *Adoration* (Plate 4) as are the exotic costumes of the Kings.

The peacock which appears so prominently here as well as in the *Saint Jerome* by Antonello (Plate 13) and the *Annunciation* by Crivelli (Plate 20) was the attribute in mythology of Juno, Queen of the gods. It was later adopted by Roman Emperors and the early Christians as a symbol of immortality and apotheosis (or resurrection), from the ancient belief that its flesh never decayed.

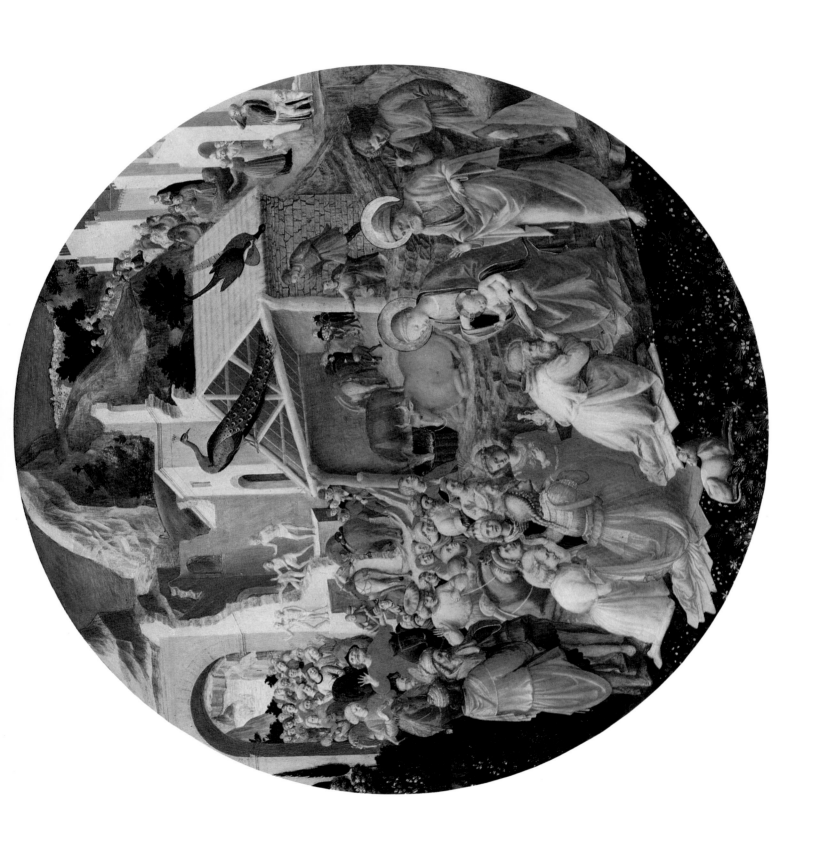

DOMENICO VENEZIANO (active 1438-61)
The Virgin and the Child with Saints
(The 'Saint Lucy Altarpiece')

c.1445. Tempera on panel, 209 x 213 cm. Florence, Uffizi

Domenico Veneziano's arrival in Florence can be dated from a letter of 1438 asking Piero de'Medici for work. Even Vasari knew little about Veneziano and invented anecdotes in his account of the artist's life, even claiming that he had been murdered by Andrea del Castagno. In fact, Castagno predeceased Domenico, dying in the plague of 1457.

Saint Zenobius, on the right, the Bishop and patron saint of Florence, stands with Saint Lucy, a virgin of Syracuse, who was denounced as a Christian by her pagan suitor Consul Paschasius. Lucy's punishment was to be sent to a brothel, but to save herself from shame she plucked out her eyes and sent them to Paschasius on a plate. She is depicted holding this plate and the palm denoting her martyrdom, picked by angels in paradise. Saint Francis' presence is particularly relevant in altarpieces of the Virgin and Child because of his Order's belief in the doctrine of the Immaculate Conception, hotly disputed with the Dominicans. Domenico uses the gesture of the other patron saint of Florence, Saint John the Baptist – 'Behold the Lamb of God' – to link the onlooker with the holy figures.

Domenico's sensitivity to light is evident in this altarpiece. A *predella* panel in the Fitzwilliam Museum, Cambridge, shows the Annunciation taking place in a charming sunlit garden, deriving its effect, as does the depiction of this open-air loggia, from a close observation of nature. It was this aspect of Domenico's art that his assistant, Piero della Francesca, would develop.

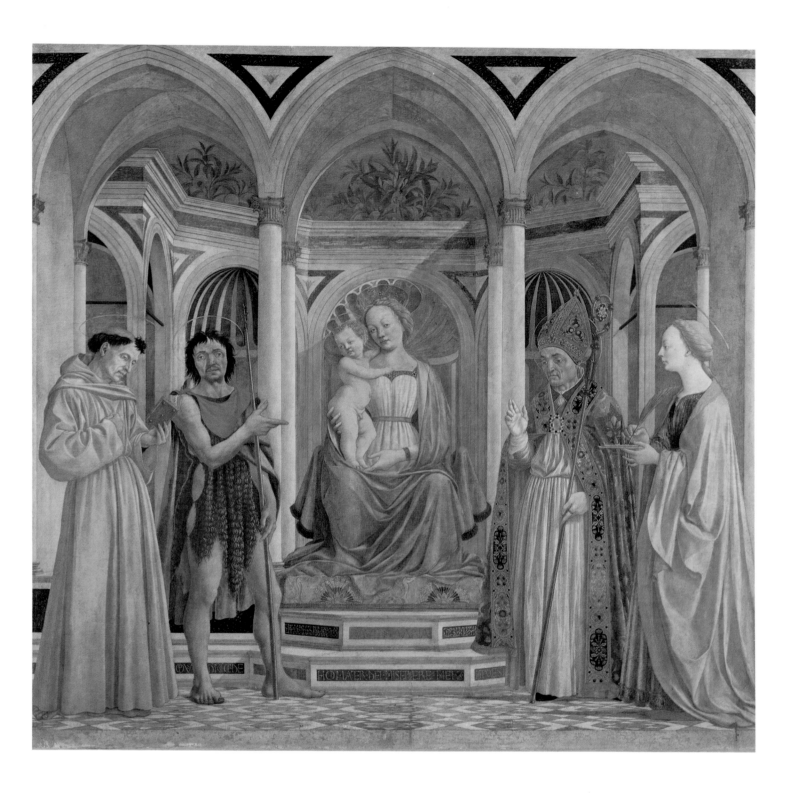

PIERO DELLA FRANCESCA
(active 1439-78, died 1492)
The Baptism of Christ

c.1450-55. Panel, 167 x 116 cm. London, National Gallery

Piero depicts a rare occurrence in the Bible, the presence of all three persons of the Trinity: at Christ's Baptism the heavens opened, the Holy Spirit descended (embodied as a dove) and a divine voice proclaimed 'Thou art My beloved Son'. God the Father is represented here by fine gold lines descending from Heaven. The altarpiece, one of Piero's earliest works, was painted for the chapel dedicated to Saint John the Baptist in the abbey of the Camaldolese Order in Borgo Sansepolcro. Borgo, his birthplace, appears in the background.

Piero had been fascinated by the costumes of the Greek members of the 1439 Council of Florence, whose strange hats are worn by the figures who point up at the heavens in the *Baptism*. While his attention to details, such as the reflections in the water, the draperies and plants (especially the ivy wound round the Baptist's belt) is minute, it does not detract from the narrative. Piero used the right-hand angel (who looks out at us) to attract our attention and direct it towards the central scene of the Baptism, a device highly recommended by Alberti.

Piero's work is characterized by solemn sculptural figures (Fig. 24). Of his treatises, one analyses the theoretical and scientific foundations of his pictures, while another, *Some questions of abacus necessary for merchants*, is purely mathematical and reveals that merchants were used to calculating volumes and would have been sensitive to the geometrical purity of shapes, volumes and ratios underlying Piero's work.

Fig. 24
Piero della Francesca
The Queen of Sheba
Adoring the Holy
Wood/The Queen
of Sheba Received
by Solomon
c.1459. Fresco. Arezzo,
San Francesco

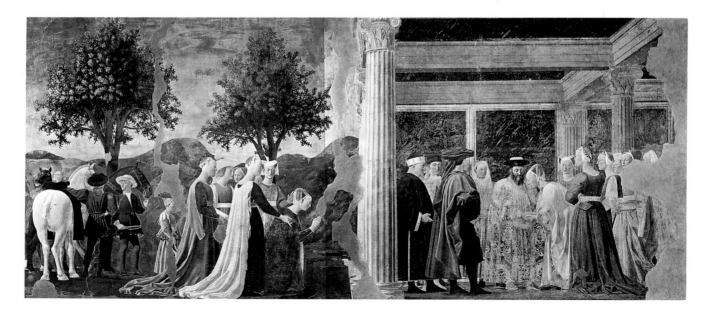

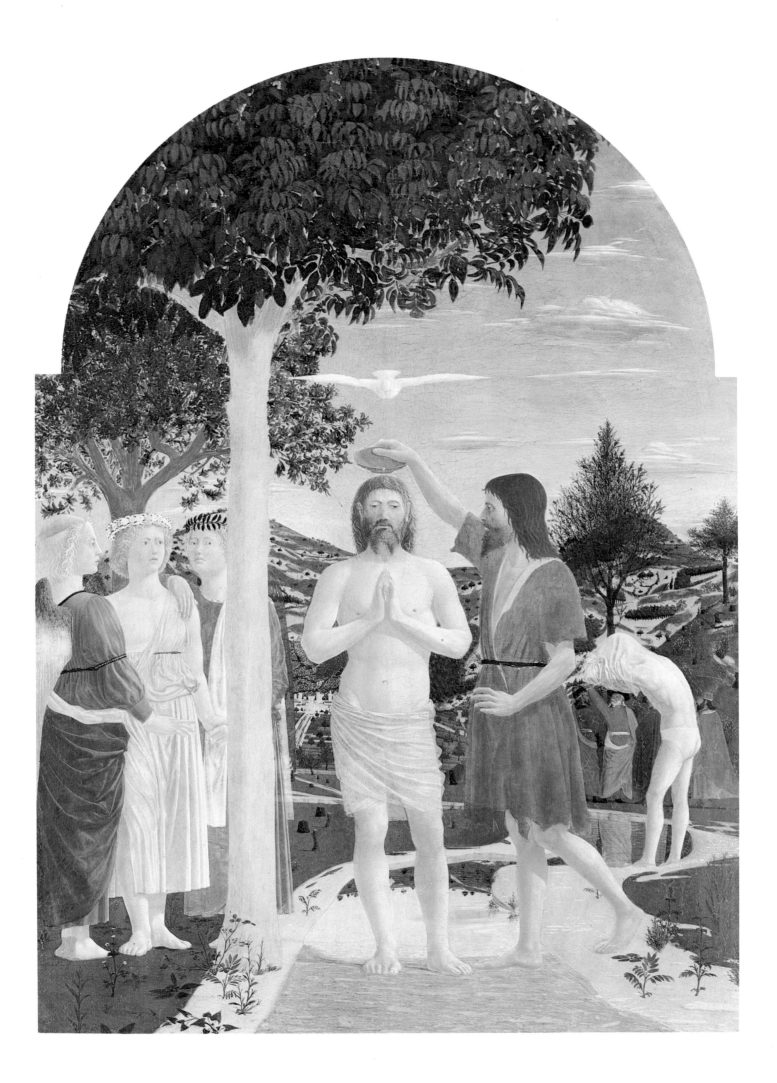

ALESSO BALDOVINETTI (c.1426-99)
Portrait of a Lady in Yellow

c.1465. Painted on panel, 62.9 x 40.6 cm. London, National Gallery

Baldovinetti, who joined the Compagnia di San Luca in Florence c.1448-49, not only painted but also worked in mosaic and stained glass. Something of his minute technique can be seen in the use of tiny dots of white paint to highlight the features of this unknown lady. The device of three tied palm leaves on her sleeve is probably armorial but has not been identified.

The use of such an austere profile – the lady almost looks like an heraldic device herself – was at odds with Renaissance artists' love of displaying their virtuosity at foreshortening and perspective. However, the profile continued to be a popular format, especially with the revival of the antique form of portrait medals. Antonello da Messina, Botticelli and Bellini were to develop the three-quarter view (Plates 22 and 27), which was to be given its greatest expression in Leonardo's *Mona Lisa* (Plate 29).

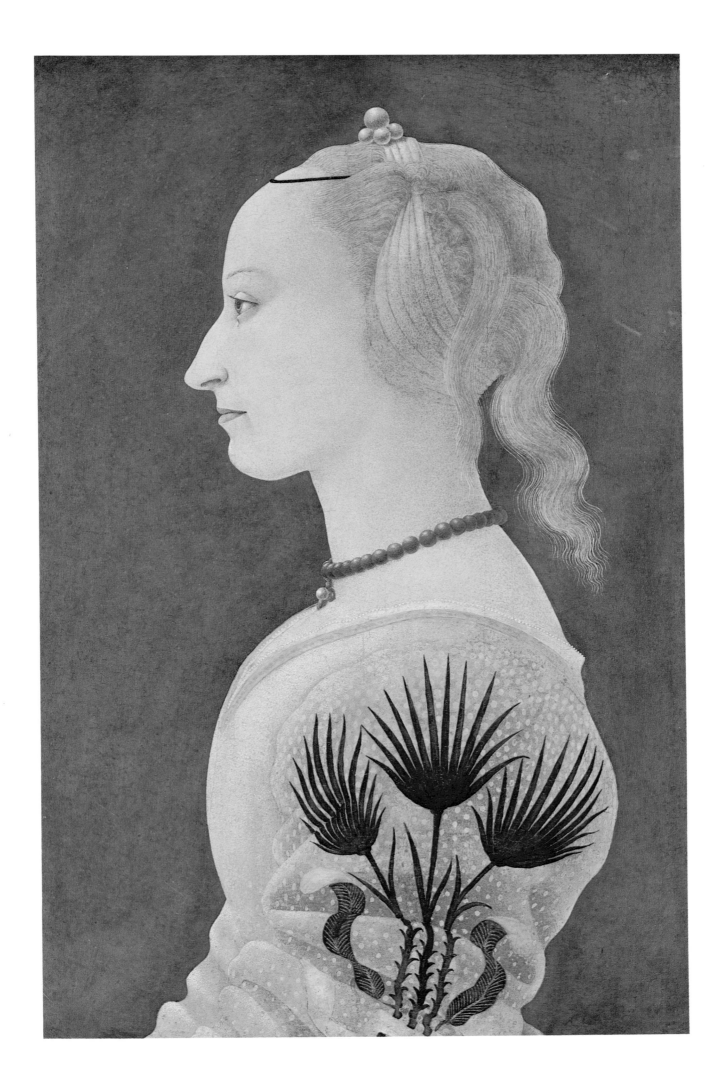

DOMENICO GHIRLANDAIO (1449-94)
Portrait of Giovanna Tornabuoni

1488. Tempera on panel, 77 x 49 cm. Lugano, Thyssen Collection

Giovanna degli Albizzi married Lorenzo Tornabuoni aged eighteen in June 1486 and died two years later in childbirth. The poignant inscription pinned above her prayer book, which can be translated, 'O Art, if thou could express her manners and her mind, there would then be no lovelier picture upon earth', suggests that the portrait was painted posthumously.

Lorenzo's father, Giovanni, had commissioned Ghirlandaio to paint a series of frescoes in the choir of Santa Maria Novella, Florence, in 1485. The contract for the series shows the extent to which he controlled the content of the pictures. Ghirlandaio agreed to include 'figures, buildings, castles, cities, mountains, hills, plains, rocks, costumes, animals, birds and beasts of every kind'; these, and the portraits of the Tornabuoni family and those of the Medici to whom they were related by marriage, almost submerge the religious subjects (Fig. 25). Giovanna appears full-length in the fresco of the *Visitation of the Virgin to Saint Elizabeth*, and this small commemorative portrait was probably copied from the fresco after her death.

Fig. 25
Domenico
Ghirlandaio
Detail of portrait
heads
c.1490. Fresco. Florence,
Santa Maria Novella

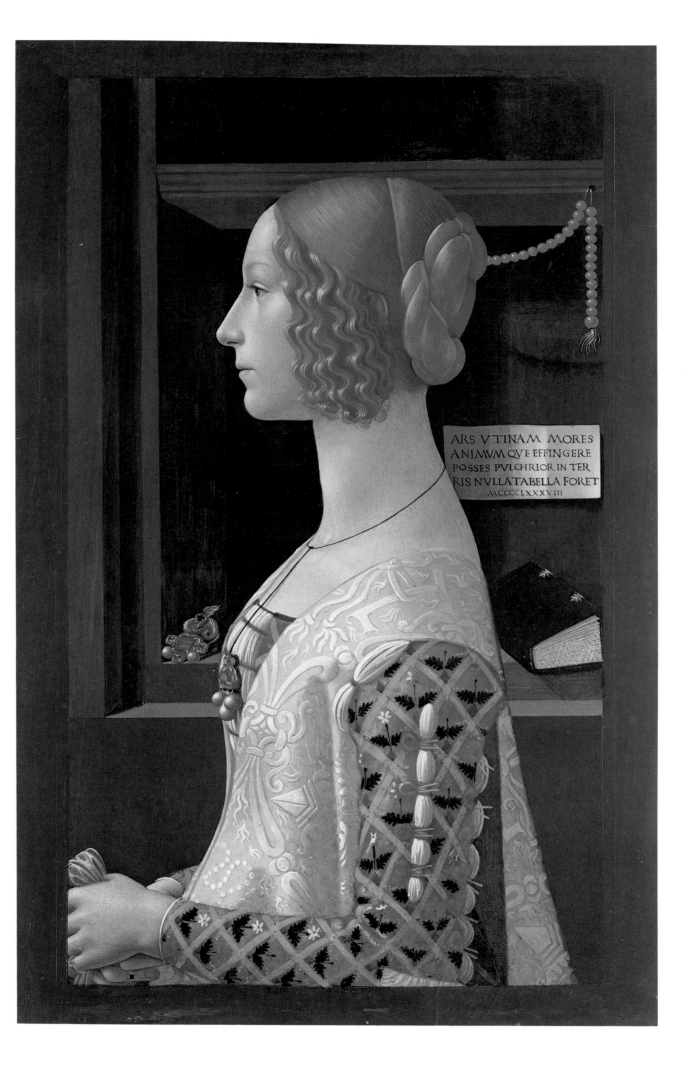

SASSETTA (c.1392-1450)
Saint Francis Renounces his Earthly Father

1437-44. Egg tempera on panel, 87.6 x 52.1 cm. London, National Gallery

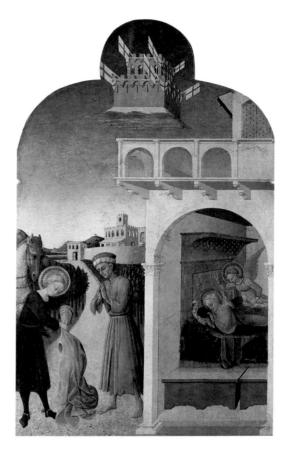

Fig. 26
Sassetta
The Dream of Saint
Francis
c.1437-44. Egg tempera
on panel, 87 x 52.5 cm.
London, National Gallery

Commissioned by the Friars of San Francesco, Borgo Sansepolcro, the altarpiece from which this panel originates was one of the most expensive commissions of *quattrocento* Siennese painting, taking seven rather than the specified four years to complete. The altarpiece is now dismembered. The Franciscan Friars lived outside the monastic world as a mendicant (literally, begging) Order whose preaching emphasized moral reform and an intense spiritual life. The back of the altarpiece shows scenes taken from the Life of Saint Francis by Saint Bonaventura. Saint Francis was born in 1181 in Assisi, the son of a rich cloth merchant, Pietro Bernardone. Francis' dissipated youth was reformed after a serious illness which inspired him to help the poor – in Fig. 26 he is seen giving his cloak to a knight who had been reduced to poverty, and dreaming of the Order which he was to found. Later, as seen in Plate 12, he tears off his clothes and is covered by the Bishop's robe, which signifies Francis' acceptance into religious life; his furious father disinherits him.

Patrons often specified what quality of paint was to be used in their commissions – ultramarine, for instance, was ground from expensive lapis lazuli imported from the Levant, and came in various grades, including a cheap imitation made from copper, called German blue. Important incidents could be highlighted by the use of gold or expensive pigments. The significance of the riches which Francis is shown discarding would have been emphasized by the use of ultramarine in the painting of his cloak. Piero della Francesca, who came from Borgo, may have been influenced by Sassetta's sensitivity to light, exemplified in Fig. 26.

13 ANTONELLO DA MESSINA
(active 1456-79)
Saint Jerome in his Study

1475. Oil on panel, 45.7 x 36.2 cm. London, National Gallery

Saint Jerome (born in 341) is depicted in art either as a penitent – he spent some years in the Syrian desert as a hermit – or as one of the four Fathers of the Church and translator of the Bible. Alberti liked a picture to be an 'open window, through which I can see what will be painted here'. Through this open window, with the texture of its stone scratched into the wet paint, we can see Saint Jerome in his study with his companion, the lion from whose paw he extracted a thorn, walking towards him. Beyond the colonnade, windows open on to a sunlit landscape, and the scene is illuminated both from these windows and that which appears to frame the picture.

The picture may date from Antonello's stay in Venice (1475-76) or may merely have been sold there. The chronicler, Marcantonio Michiel, described it in a Venetian collection in 1529: 'The little picture of Saint Jerome reading in his study in Cardinal's attire, believed by some to be by the hand of Antonello of Messina: but more, and with better judgement, attribute it to Jan van Eyck or to Memlinc, the old master from the Netherlands, and it is in their manner, though the face is finished in the Italian style and therefore seems to be by the hand of Jacometto.' Both the landscapes, which include fishermen on the lake, and the casually arranged books and objects in the Saint's study could have been mistaken for the work of a northern artist. It was this 'northern' skill in oil painting, together with an Italian sense of form, that Antonello brought to Venice with such far-reaching results.

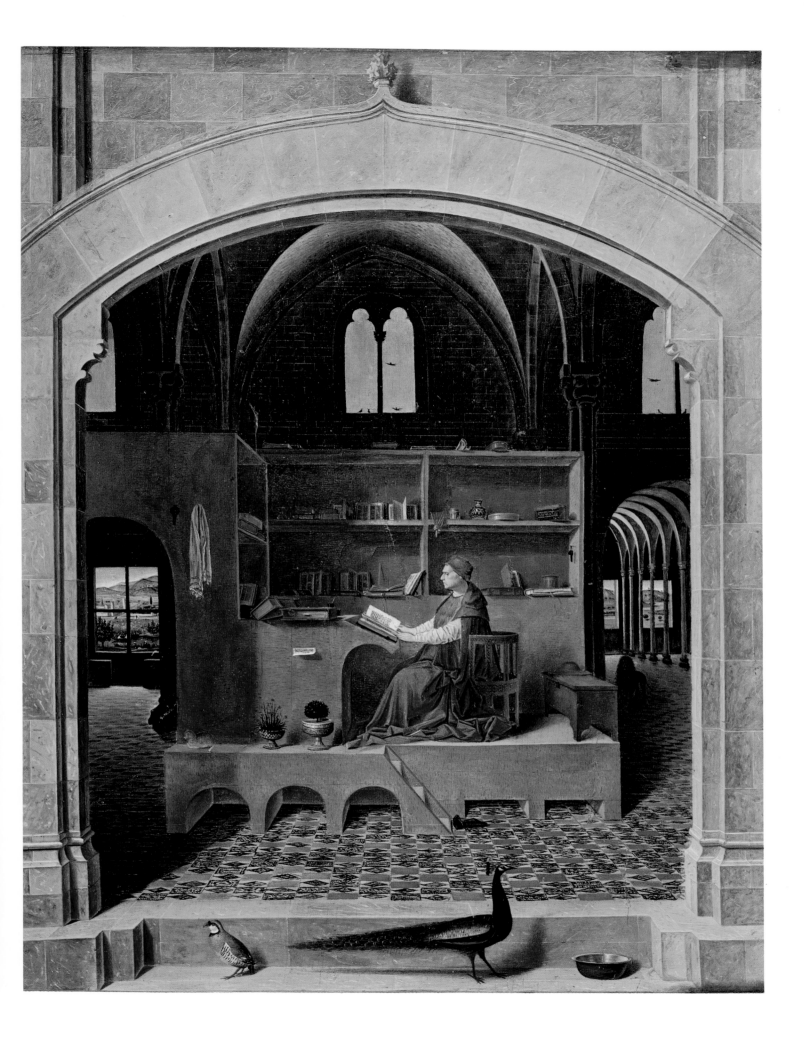

14

PAOLO UCCELLO (c.1397-1475)
Niccolò Mauruzi da Tolentino at the Battle of San Romano

c.1450s. Egg tempera on panel, 182 x 320 cm. London, National Gallery

This is one of three panels commemorating the Battle of San Romano (the others are now held in the Uffizi and the Louvre) that were listed in an inventory of 1492 as being in a ground floor room in the Palazzo Medici. The battle was a minor one that took place on 1 June 1432, in which the Florentines, led by Niccolò da Tolentino (seen here on his white charger) defeated the Siennese, commanded by Bernardino della Ciarda. Though undoubtedly dangerous (Bernardino della Ciarda is shown being un-horsed in the Uffizi panel), these *quattrocento* battles took place in the countryside and involved only *condottieri*. Rulers were grateful to such men and Niccolò da Tolentino (c.1350-1435) was given a state funeral in the presence of Pope Eugenius IV and commemorated in an equestrian portrait by Andrea del Castagno in the Duomo.

The painter Uccello was a most engaging character; Vasari relates that he was so gripped by the science of perspective that his wife had difficulty persuading him to come to bed. In these paintings he used every device possible to depict spatial recession – fallen soldiers, horses and broken lances – but the effect remains one of decorative pattern, the action frozen. Uccello delighted in painting the detail of the orange grove, the soldiers' armour – now tarnished but originally silver leaf – and the harnesses stamped in gold (artists were employed to decorate saddlery for tournaments), and most particularly in the splendid *mazzocchi* or brocade hats worn by Niccolò and by Michelotto da Cotignola (in the Louvre panel). The backgrounds of the Tuscan countryside are particularly charming.

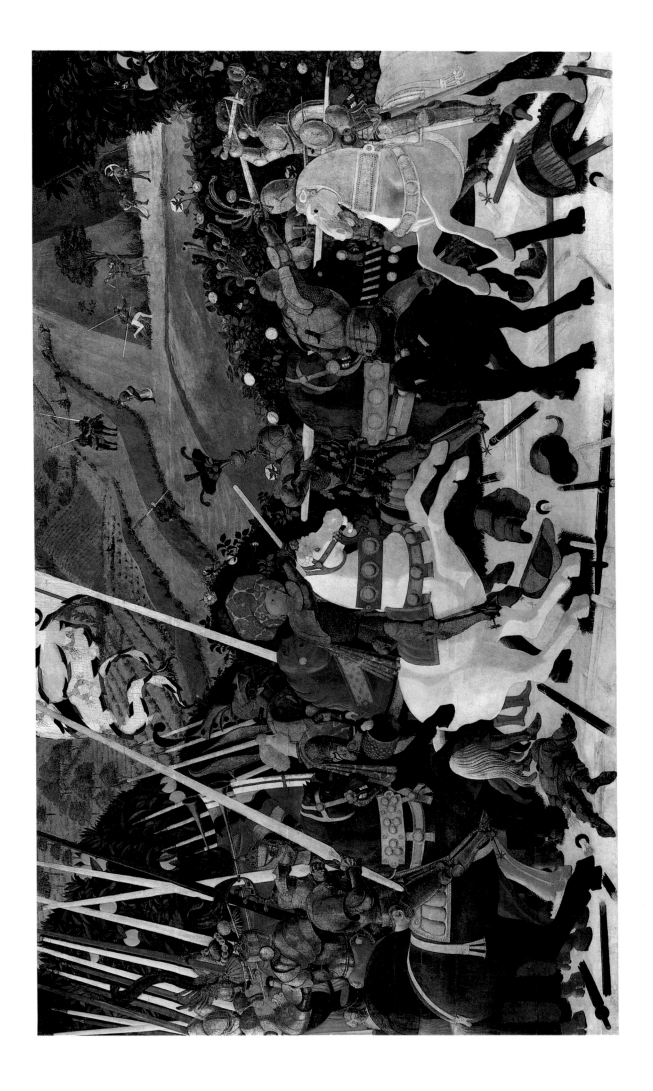

PIERO DI COSIMO (1461/2-1521)
A Forest Fire

c.1487-89. Oil on panel, 71 x 203 cm. Oxford, Ashmolean Museum

This panel is probably one described by Vasari: 'around an apartment in the house of Francesco del Pugliese he did a variety of scenes with little figures; and it is impossible to convey all the diversity of the fantastic things that he took delight in painting ... which came into his mind, being stories drawn from fables.' For Giovanni Vespuci 'he did some bacchanalian scenes ... in which he painted such strange fauns, satyrs, and wood-nymphs, and *putti*, and Bacchantes...' (Fig. 27).

A forest fire is described in the fifth book of Lucretius, in which the discovery of fire is attributed to the accidental rubbing together of branches. Two of the animals depicted have human features: Democritus relates that Nature could not at first decide how features should appear. Vasari reported that Piero was fascinated by oddities and 'frequently took himself off to see animals or plants or other things that nature often creates accidentally or from caprice, and he derived from these a pleasure and satisfaction that completely robbed him of his senses'. It was an age in which the creatures of mythology were not perhaps so very different from the bizarre discoveries that explorers like Columbus expected to make. This was one of the first pictures of the Renaissance in which Man had no importance. The unorthodox subject accords with Vasari's description of Piero as more brute beast than human being: 'he cared nothing for his creature comforts and reduced himself to eating only boiled eggs which, to economize on fire, he used to cook whenever he was boiling glue ... fifty at a time.'

Fig. 27
Piero di Cosimo
Old and Young
Satyrs in a Tree
(Detail from 'The
Discovery of Honey')
c.1505-7. Tempera on
panel, 80 x 128.5 cm.
Massachusetts, Worcester
Art Museum

GIOVANNI BELLINI (active c.1459-1516)
The Agony in the Garden

c.1465. Egg tempera on panel, 81.3 x 127 cm. London, National Gallery

Bellini's composition is partly based on a drawing by his father, Jacopo. It is also obviously closely related to Mantegna's painting of around the same date (Plate 17), although it is not known why the two artists should both have chosen to paint the same composition. Giovanni was apparently in awe of his formidable brother-in-law, although this painting already shows the gentle luminous character which his art was later to develop. The figures of the sleeping disciples, which are so sculpturally composed in Mantegna's picture, are subordinate here to the figure of the kneeling Christ, dramatically silhouetted against the sky. An ethereal angel holds the cup which Christ prays to be taken away from Him.

Bellini is more sensitive than Mantegna to the texture of things, such as the folds of Christ's robes highlighted with gold, the rippled surface of the water, and the wattle fence opening onto a garden such as that which might be found in a medieval Book of Hours. Mantegna's *Agony in the Garden* is less specific about which particular moment of the vigil is depicted, whereas Bellini uses the emotional potential of atmosphere to heighten the tragedy: as the captors advance, the rosy beginnings of dawn tinge the clouds and landscape with light.

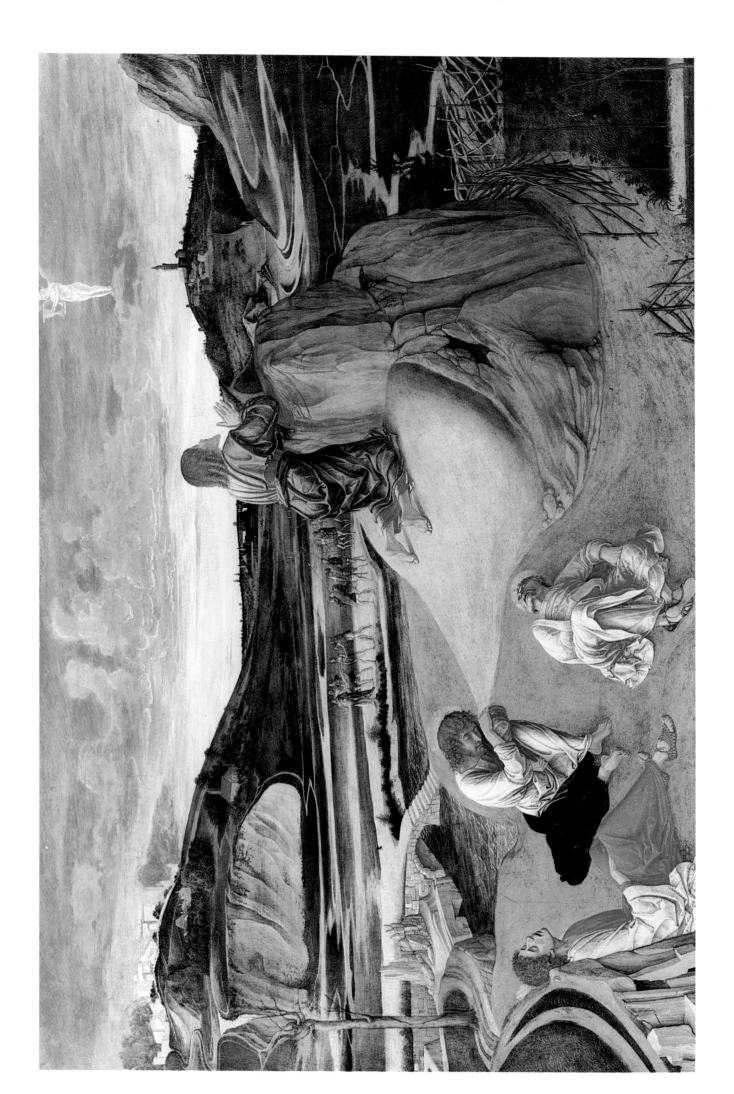

ANDREA MANTEGNA (c.1430-1506)
The Agony in the Garden

c.1460. Egg tempera on panel, 63 x 80 cm. London, National Gallery

More technically accomplished than Bellini, Mantegna displays his grasp of foreshortening and placing figures in space, particularly evident in the sleeping saints, Peter, James and John. Something of the drama Bellini achieved by silhouetting Christ's head against the sky has been lost here, with Christ placed directly in front of the background mountains. Unlike the ethereal angel in Bellini's picture, Mantegna's bearers of the instruments of the Passion appear distinctly corporeal.

The portrayal of the barren landscape is well suited to Mantegna's hard linear style, and the attention to detail is extraordinary for the tempera medium. In the background Jerusalem's city walls have recently been mended, earth clings to the roots of the upturned tree, rabbits play on the path and the foreground is scattered with tiny pebbles. Mantegna reveals his fascination with the antique in the equestrian statue in the city and in the armour worn by the High Priest's men, who are being led to the Garden of Gethsemane by Christ's betrayer, Judas Iscariot. The bizarre mountains have been identified by some as the Dolomites and the city itself certainly contains elements of Italian walled towns, such as the towers. But, whereas Mantegna has attempted to create Jerusalem at the time of the Romans, Bellini shows no interest in historical accuracy portraying instead a hill town of the Veneto, of outstanding beauty.

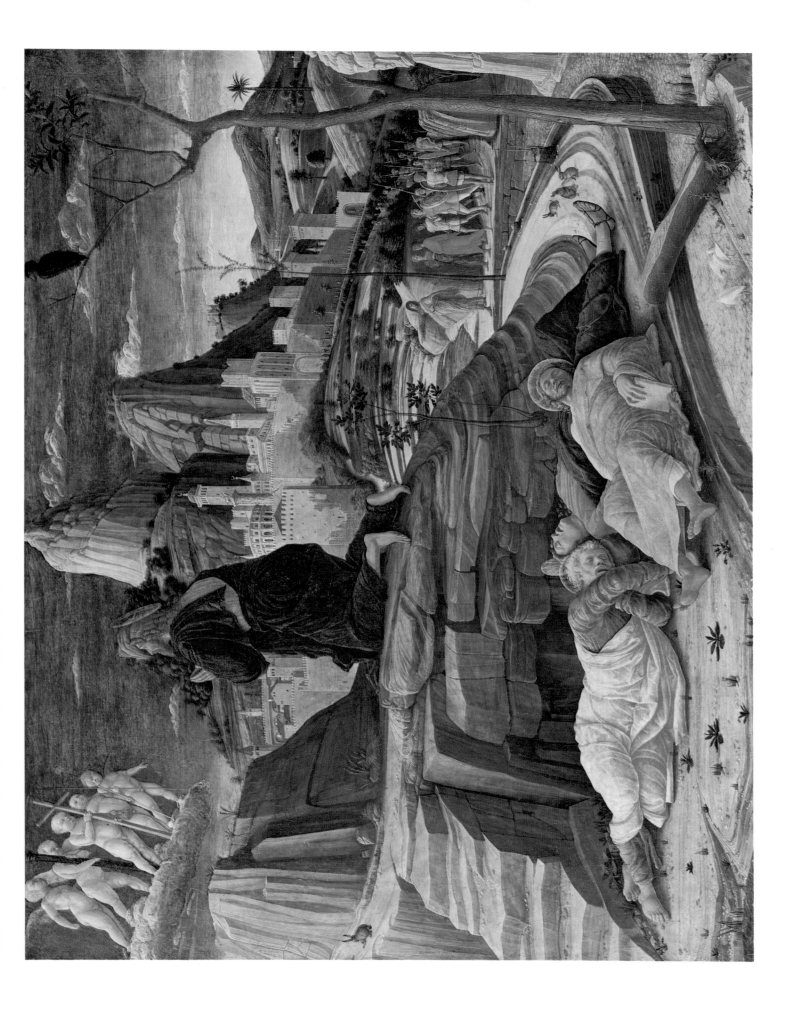

COSIMO TURA (active c.1450-95)
The Virgin and Child Enthroned

c.1475-76. Oil and egg tempera on panel, 239 x 102 cm. London, National Gallery

This painting formed the centre of the altarpiece in the church of San Giorgio fuori le mura (St George outside the walls) at Ferrara, commissioned by the powerful Roverella family. The partly visible inscription on the organ may refer to Lorenzo Roverella (who died in 1474), knocking to ask admittance into paradise. Cosimo Tura was the court artist of the Este family at Ferrara, which flourished as a centre for painting only in the second half of the fifteenth century. Tura died in poverty, having been superseded as Court Painter by Ercole de'Roberti in 1486.

The fantastic throne, placed on steps which would surely collapse, is ornamented with the tablets of stone bearing the Ten Commandments and surmounted with the symbols of the four evangelists: the winged lion of Saint Mark, the winged ox of Saint Luke, the eagle of Saint John and the angel reading who represents Saint Matthew. In the bizarre ornament of the capitals and throne, loosely derived from the antique, Tura used the same drawing in reverse to achieve symmetrical pairs of figures and forms. The bright colouring, particularly of the architecture (not to be found in even the most livid Italian marble), is typical of Tura's individualistic work. The hardness of his style is partly accounted for by the oil medium and by the early influence of Mantegna, and it remains austere despite the elaborate ornamentation.

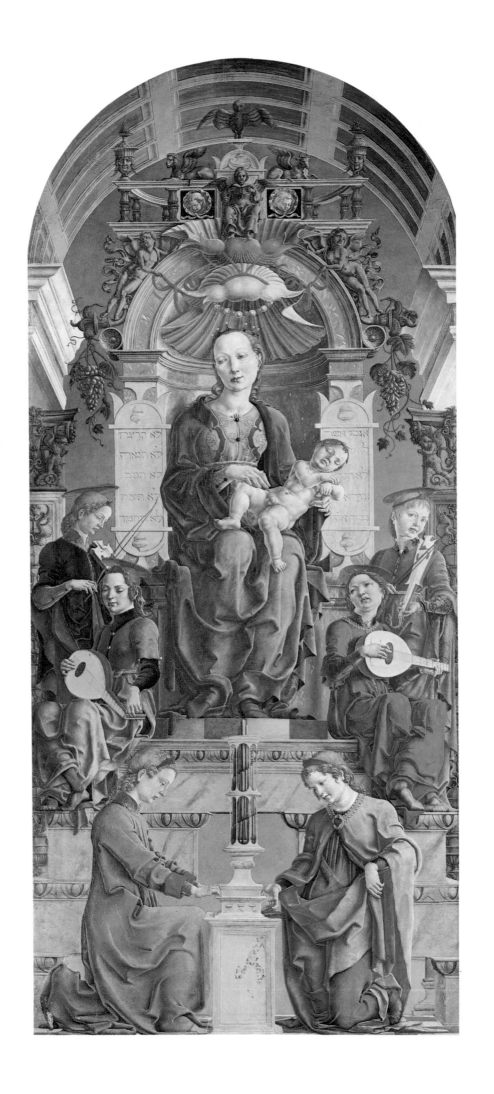

ANTONIO (c.1432-98) and PIERO POLLAIUOLO (c.1441-96)
The Martyrdom of Saint Sebastian

c.1475. Oil on panel, 291.5 x 202.5 cm. London, National Gallery

Antonio Pucci, the patron of the Oratory of Saint Sebastian, commissioned this altarpiece. The Oratory was attached to the Servite church of SS Annunziata in Florence, where the Saint's arm bone was kept as a relic. Pucci's emblem, a Moor's head, can be seen in the roundels of the triumphal arch in the background.

Sebastian, a secret Christian, was a young nobleman in the Prætorian Guard and a favourite of the Emperor Diocletian. After the torture of Christian friends Sebastian declared his belief and was condemned to be killed with arrows; left for dead, he was rescued by Saint Irene. Saint Sebastian was invoked against the plague (which was to kill many artists, including Castagno, Giorgione and Titian).

Vasari tells us that the model for the Saint was Gino di Lodovico Capponi (Florentines were used to seeing young nobles in the guise of saints in religious processions). The executioners are arranged in a symmetrical pattern, and Vasari particularly praised the depiction of the archer in the foreground, who strains to load his crossbow and uses 'all the force that a man of strong arm can exert in loading that weapon, for we can perceive in him the swelling of his veins and muscles, and how he holds his breath to exert more force'. The other foreground archer's pose is the same, reused in reverse. To obviate the need for a middle distance, which the artists still found difficulty in portraying, the figures are placed on a plateau. The Pollaiuoli's interest in, and depiction of, the landscape of the Arno valley, particularly the shimmering river and its rapids, was unusual in Florence.

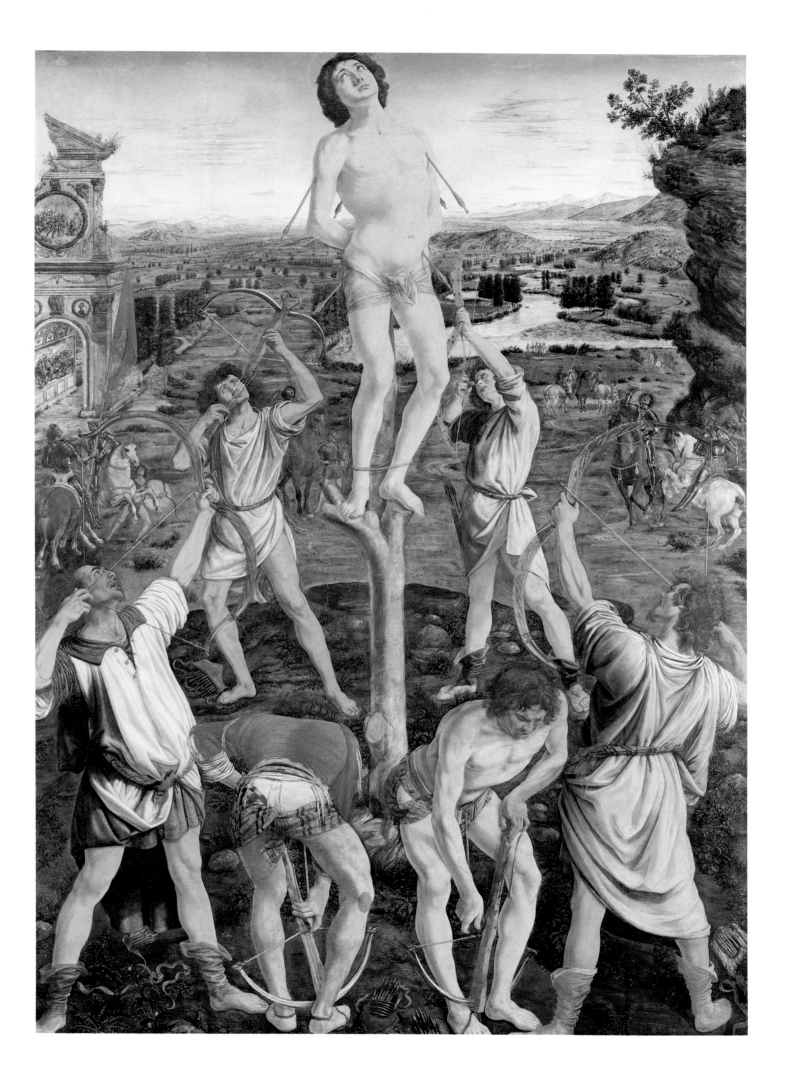

CARLO CRIVELLI (active 1457-93)
The Annunciation with Saint Emidius

1486. Egg tempera on panel transferred to canvas, 207 x 146.5 cm.
London, National Gallery

This altarpiece was painted for the Church of the Annunciation at Ascoli Piceno, where Crivelli lived in later life. Its unusual depiction of the Annunciation taking place in a narrow city street contains several parallel elements. The city of Ascoli Piceno was granted certain rights of self government by Sixtus IV in 1482, on the Feast of the Annunciation, 25 March. The name of the Papal Bull is inscribed in the painted ledge below the picture, together with the arms of Sixtus' successor, Innocent VIII. The message of the Holy Spirit embodied in the divine dove has a counterpart in one brought by carrier-pigeon to the man on the bridge. The figure shading his eyes has obviously also seen the divine light (which enters the Virgin's house through a convenient opening above the window), although he does not seem to have noticed the presence in the street of Saint Emidius (holding a model of the city), who kneels and gazes intently at the Angel Gabriel. The inclusion of an attendant saint, in this case Ascoli Piceno's obscure patron saint (who was also invoked against earthquakes), is unusual.

Every surface of the picture has been elaborated, from the architectural ornament and the dovecote high up on the left, to the still-life treatment of the objects in Our Lady's house. Like Mantegna (Plate 17) Crivelli has enjoyed depicting a wall in the background which has recently been repaired.

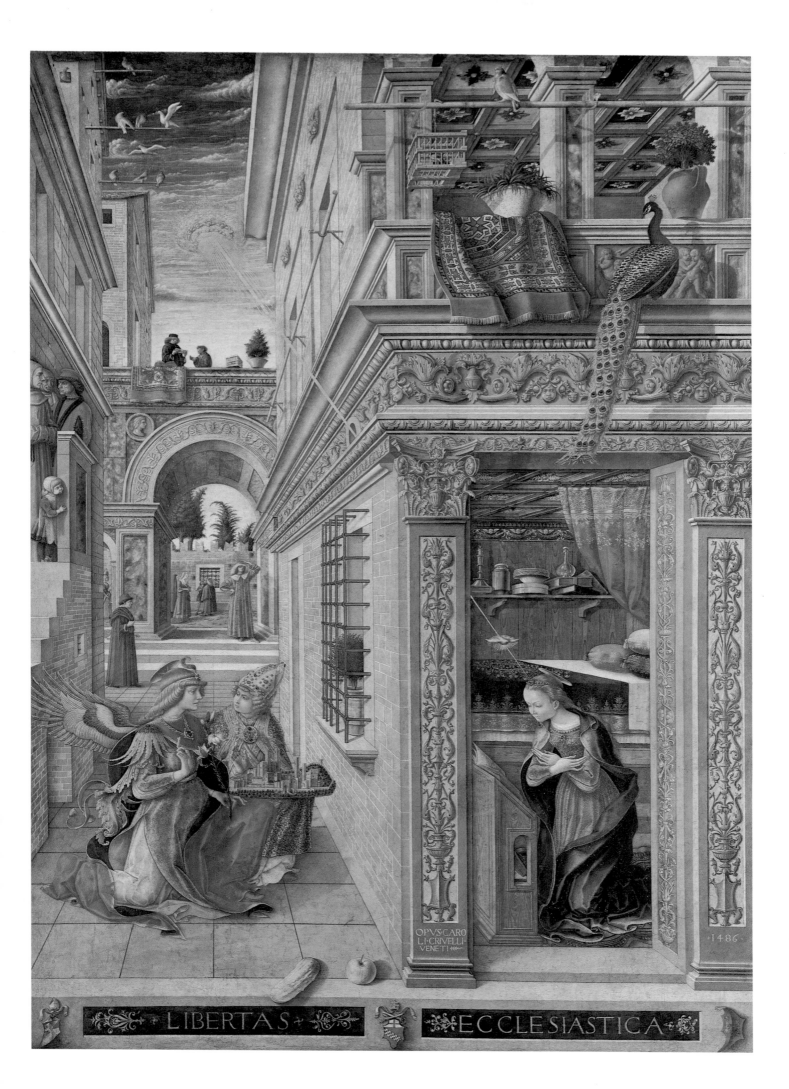

LEONARDO DA VINCI (1452-1519)
The Virgin of the Rocks

c.1480. Oil on panel transferred to canvas, 197 x 119.5 cm. Paris, Musée du Louvre

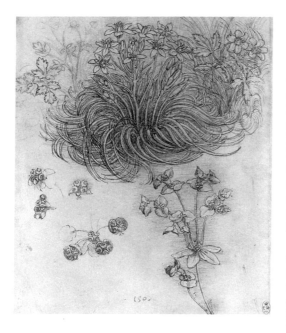

Fig. 28
Leonardo da Vinci
Study of Flowering
Plants
c.1506. Pen and ink over
red chalk, 19.8 x 16 cm.
Windsor, Royal Collection
(reproduced by gracious
permission of Her Majesty
the Queen)

The circumstances of this commission were by no means straightforward. In 1483 the Confraternity of the Immaculate Conception in San Francesco, Milan, commissioned an altarpiece of the Virgin and Saints to be completed by Leonardo by the following Feast of the Conception. Still unfinished by 1490, the Confraternity took possession of the picture and made Leonardo finish it and also paint a second version on his return to Milan in 1506. The first, illustrated here, was sold to the King of France, and the second, now in the National Gallery, replaced it as the altarpiece. For some reason Leonardo replaced the commissioned subject with one he had been devising in Florence. There is no scriptural authority for the representation of the cousins together before the Baptism, only apocryphal stories of a rural meeting after the Egyptian sojourn. But the use of a cave gave Leonardo the opportunity to depict scientifically observed rock formations and plants (Fig. 28), which he combined with the idealized unearthly beauty of the Holy figures.

Leonardo's famous crepuscular light is exaggerated in the now much darkened Paris version, although the scene is open to the sky and was originally lighter than the London picture, where the rocks fill the picture and give the figures greater chiaroscuro. Leonardo made significant changes to the later composition; in the London version the angel no longer points at the Baptist but gazes at him, instead of at the beholder. Leonardo had studied Alberti, who made particular reference to gesture and its control over the spectator's gaze, and these precepts are evident in the arrangement of hands above Christ's head as He blesses the Baptist.

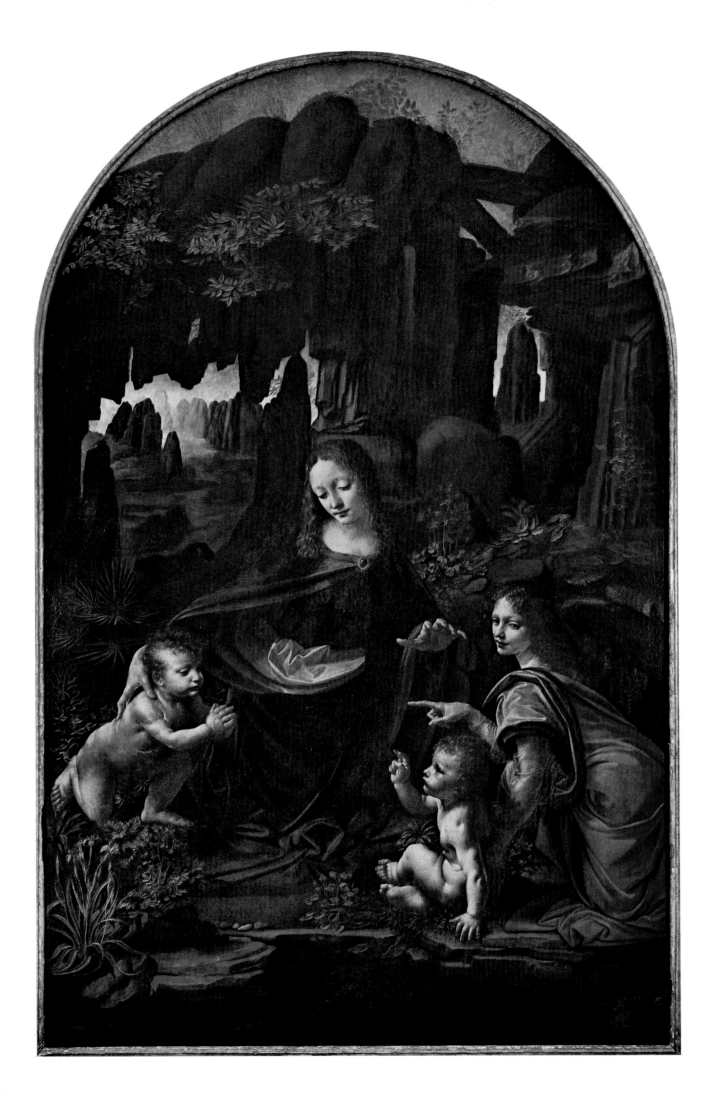

ANTONELLO DA MESSINA
(active 1445-79)
Portrait of a Man

c.1475. Oil on panel, 35.6 x 25.5 cm. London, National Gallery

The Flemish influence on Antonello is paramount in this portrait. He uses the three-quarters view common in northern European portraiture to give the head greater volume and expression than is usually possible with the profile (see Plates 10 and 11), although an artist of such sensitivity to volume as Piero della Francesca was able to convey a sculptural quality in his profiles of Federigo da Montefeltro and Battista Sforza (Fig. 9). Antonello used the opportunity afforded by oil paint to change the composition: X-rays reveal that the sitter's eyes originally looked to the left, rather than out at the spectator. In 1532 Marcantonio Michiel wrote of two Antonello portraits owned by Antonio Pasqualino that 'have great power and vivacity, especially in the eyes'.

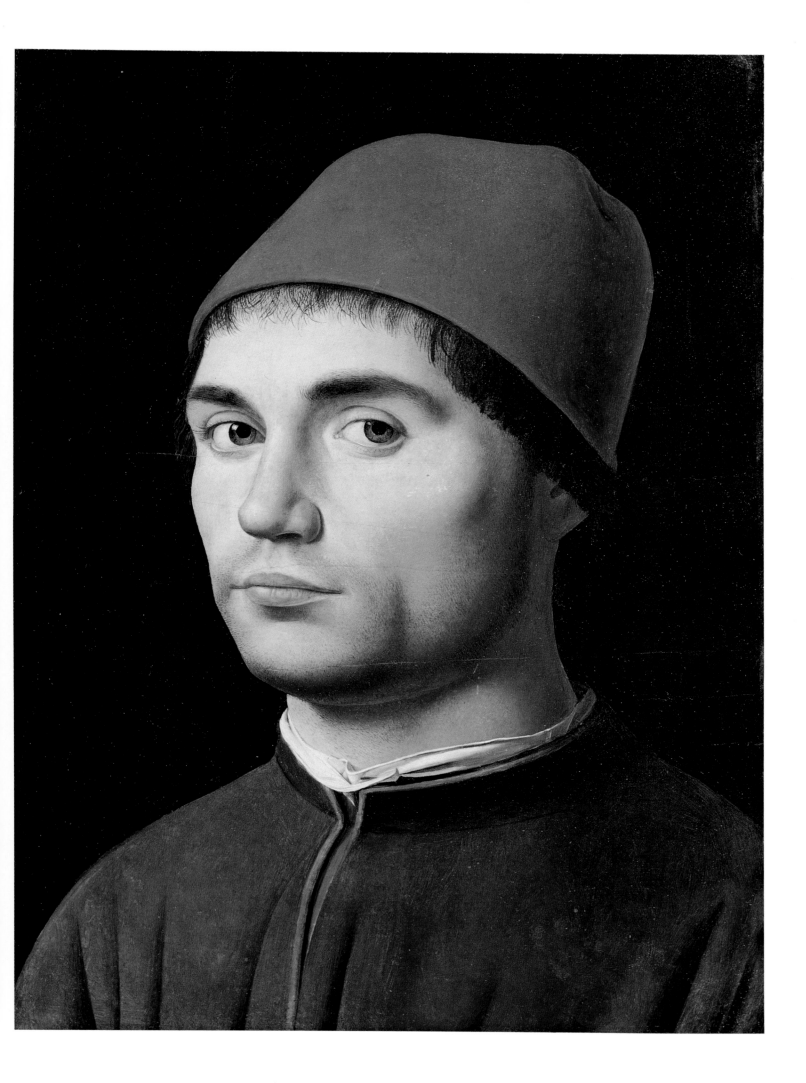

SANDRO BOTTICELLI (c.1445-1510)
Portrait of a Young Man

c.1480. Tempera on panel, 37.5 x 28.3 cm. London, National Gallery

There is an air of mystery shrouding this portrait, not only because we do not know the identity of the sitter, but because in his portraits Botticelli seemed to have been intent on penetrating to the essence of his subjects' personalities. Here he has depicted the sitter frontally (a very unusual approach at the time), placing him off-centre and employing a low viewpoint so that the onlooker avoids his glance, to slightly unnerving effect.

Botticelli himself fixes us with a direct gaze in his self-portrait in *The Adoration of the Magi* in the Uffizi (Fig. 29), probably painted for Giovanni (or Gaspare) di Zanobi Lami for the church of Santa Maria Novella. The family had close ties with the Medici who are depicted in the scene with other members of the Platonic Academy. In this detail we can see Lorenzo Tornabuoni, behind Botticelli with a feather in his hat, the bearded Joannis Argiropulos in front of him, to his right Filippo Strozzi looking out of the picture, and Giuliano de'Medici in profile. The Florentine Republic was to commission Botticelli to paint Giuliano's murderers, the Pazzi conspirators, as their bodies were displayed hanging on the walls of the Palazzo Vecchio in 1478. The bloody events which undermined the humanist atmosphere created by the Medici form a perturbing background to these portraits.

Fig. 29
Sandro Botticelli
Detail from
'The Adoration
of the Magi'
c.1475-77. Tempera on
panel, 111 x 134 cm.
Florence, Uffizi

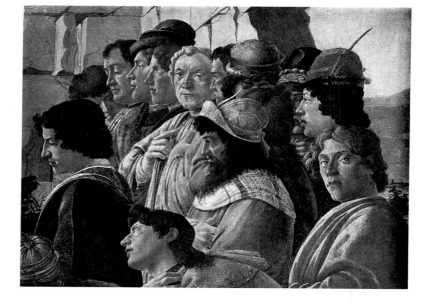

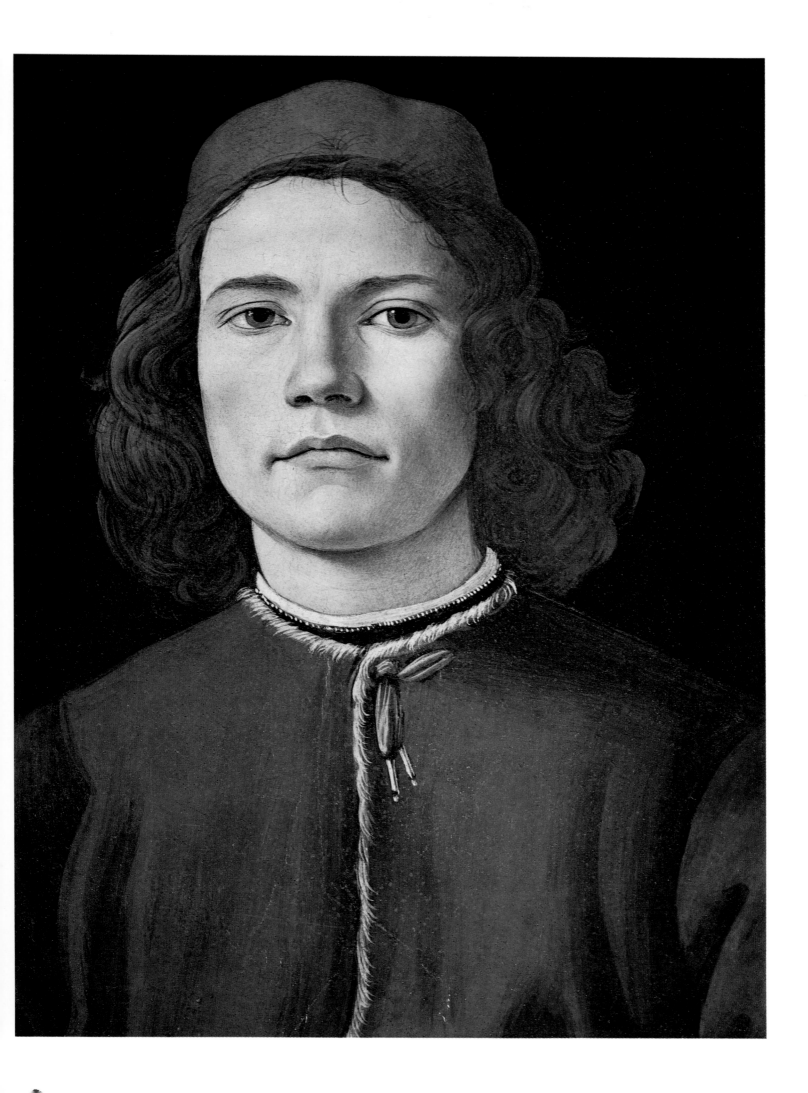

ANDREA DEL CASTAGNO
(active c.1442-57)
The Young David

c.1450. Leather on wood, 115.6 x 76.9 x 41 cm. Washington, National Gallery of Art,
Widener Collection

We know that Lorenzo de'Medici entertained the citizens of Florence
with pageantry, and 'in those peaceful days always kept his city feasting,
and there were often to be seen jousts and representations of ancient
deeds and triumphs'. He introduced the French tournament into
Florence, an event described by Niccolò Machiavelli as 'a scuffle of men
on horseback in which the leading young men of the city contended with
the most renowned cavaliers of Italy; and among the Florentine youth the
most famous was Lorenzo, who carried off the prize not only by favour but
by his own valour'. Machiavelli attributed to Lorenzo's love of spectacle
the more sinister intention of diverting the people from politics.

Vasari described the effect that the work of artists contributed to these
pageants: 'It was certainly very splendid to see, by night, twenty-five or
thirty pairs of horse, very richly caparisoned, with their riders in costume
according to the theme that had been devised, and six or eight grooms for
each one, clothed in the same livery, with torches in their hands, some-
times numbering more than 400; and then the triumphal chariot covered
with ornaments, spoils or most bizarre and fanciful objects: altogether
something that sharpens men's minds and gives great pleasure and satis-
faction to the people.'

This work by Castagno is a rare, slightly earlier survival of a parade
shield. David's dynamic pose is taken from the colossal antique nude
statues of the Dioscuri that had remained visible on the Quirinal in Rome
throughout the Middle Ages. David was a popular symbol for Florence for
his intolerance of tyranny.

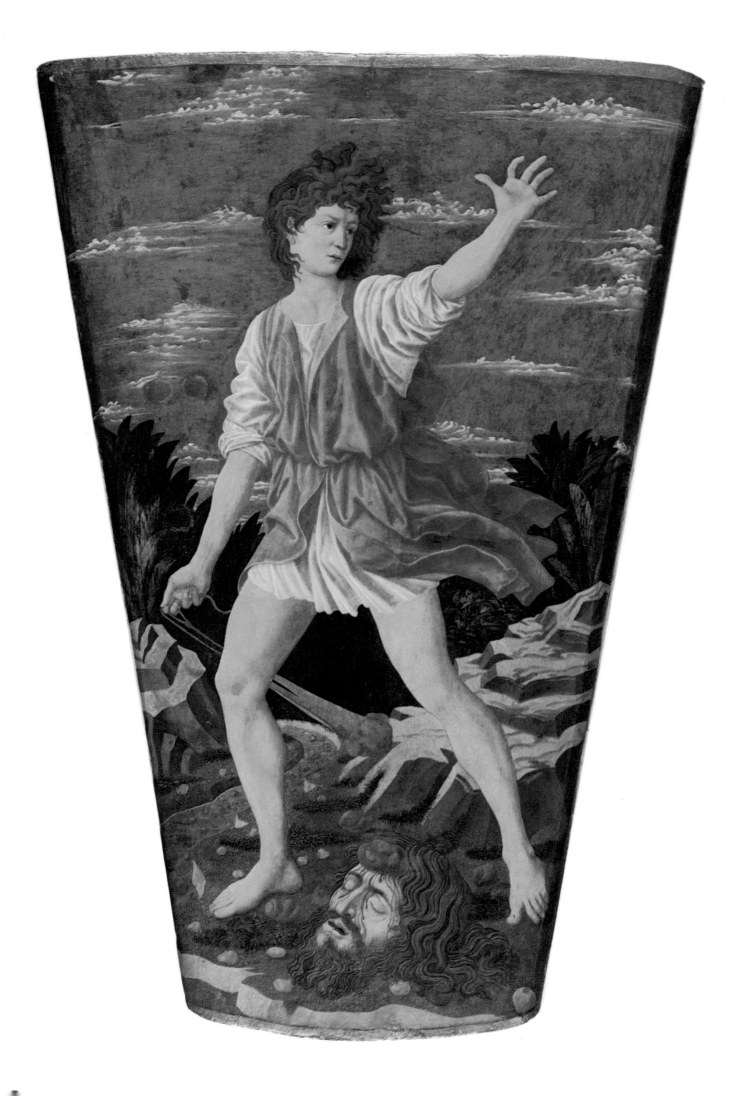

ANDREA MANTEGNA (c.1430-1506)
The Return from Rome of Cardinal
Francesco Gonzaga

1474. Fresco. Mantua, Ducal Palace

On the walls of the Camera degli Sposi in the Ducal Palace, Mantegna painted informal life-size portraits of the Gonzaga family. Here, in a loggia revealed by the drawing back of a curtain, Ludovico Gonzaga, the second Marquis, is seen holding up his hand in greeting to his son, Cardinal Francesco Gonzaga. The Cardinal holds the hand of his young brother, Ludovico, Protonotary and future Bishop of Mantua, who in turn holds that of his nephew, Sigismondo, also a future Cardinal. The other small boy is the latter's brother, Francesco, the future fourth Marquis. Their father Federigo, the third Marquis, stands to the far right. Looking out of the picture is Christian I, King of Denmark (the brother-in-law of Ludovico's wife Barbara of Brandenburg) and, in profile, Frederick III, Holy Roman Emperor. Some idea of the esteem in which Italian rulers held themselves is given by the relegation of these portraits of monarchs to the background. The Duke of Milan was furious that 'the two most wretched men in Europe' were included while he himself was omitted.

It is unlikely that the meeting depicted was a specific one; King Christian and the Emperor were never present in Italy together, and it seems that portraits were added as the work progressed. This scene is perhaps a sequel to the *Court Scene* on the adjacent wall, where the Marquis is shown being brought a message, traditionally believed to be the news of his son's elevation to the Cardinalate in 1461.

The arms over the gate in the background are those of the Gonzaga family, although the city is as imaginary as the landscape (which certainly does not represent the flat terrain around Mantua). Mantegna's lively portrait style derived from Roman busts and medals.

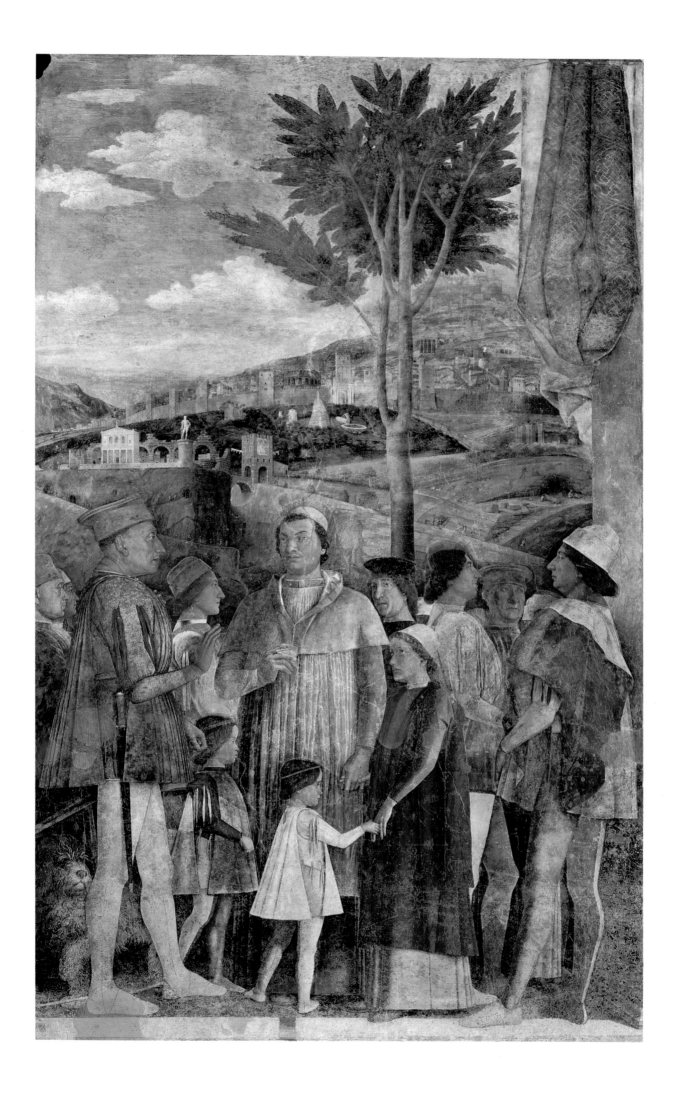

SANDRO BOTTICELLI (c.1445-1510)
The Birth of Venus

c.1490. Tempera on canvas, 175 x 278 cm. Florence, Uffizi

According to Hesiod, Venus was born of the sea's foam and floated ashore on a scallop shell propelled by the gentle breezes of Zephyr and Chloris, finally landing at Paphos in Cyprus. The figure of Venus is based on the account of the fabled classical artist Apelles' lost painting of Venus rising from the sea and wringing out her hair. Zephyr and Chloris are taken from the flying figures on Lorenzo de'Medici's most prized possession, the Tazza Farnese, a bowl of carved semi-precious stone which he bought in 1471. In the *Primavera* (Fig. 30) Botticelli depicts Venus gesturing us into her world, perhaps to contemplate divine beauty. Her handmaidens, the three graces, Aglaia, Euphrosyne and Thalia, dance, and above her, blindfold Cupid shoots an arrow. To the left Mercury disperses the clouds with his staff or caduceus, while to the right Chloris flees from Zephyr. As he embraces her, flowers, the earthly counterpart of the heavenly stars, spill from her mouth and she is transformed into the goddess, Flora, who stands beside her. The beauty with which Botticelli depicts the orange grove behind them, the flowery sward and the translucent draperies blown by the wind, is masterly.

Both pictures were painted for the Villa Castello of Lorenzo di Pierfrancesco de'Medici, and Florentine humanists would have found much of the symbolism in them twofold: Venus could represent both pagan love and the humanist ideal of spiritual love. In this context, the graces represented Chastity, Beauty and Love.

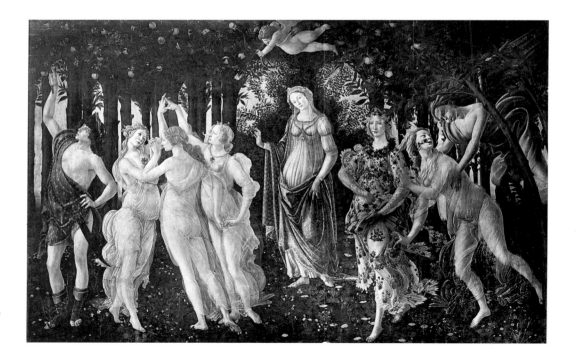

Fig. 30
Sandro Botticelli
Primavera
1478. Tempera on canvas,
203 x 313.6 cm. Florence,
Uffizi

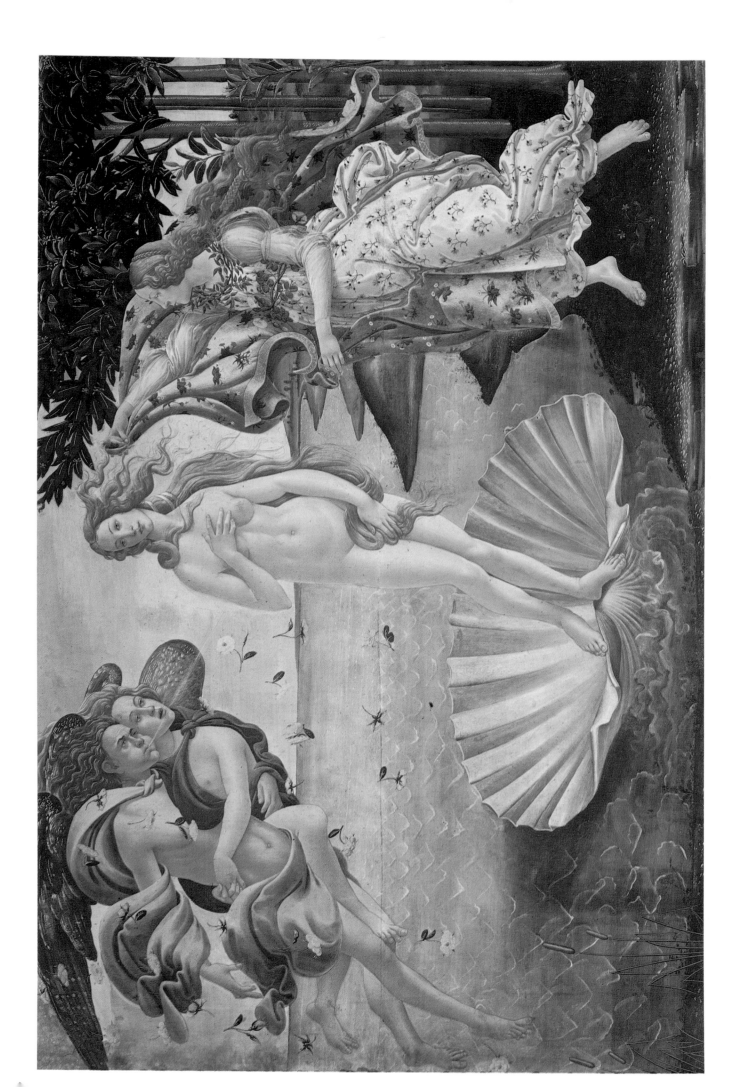

27

GIOVANNI BELLINI (active c.1459-1516)
The Doge Leonardo Loredan

c.1501-5. Oil on panel, 61.5 x 45 cm. London, National Gallery

Bellini has signed this picture as though on a piece of folded paper attached to the parapet. Such details as this, the wrinkles on the Doge's face and the damask of his robes were made possible by the use of the oil paint that Antonello da Messina had introduced to Venice. The texture of the cloth and the gold threads are conveyed not with gold paint (which Bellini used freely in his early career – see the highlights on Christ's robe in Plate 16) but with *impasto* brushwork.

The simple pose was one often used in contemporary Venetian portrait busts, and it is this sculptural quality, together with a northern-style depiction of detail, that distinguishes Bellini's portraits.

The Doge was the elected ruler of the republican oligarchy of Venice. The stability of the Serenissima was the wonder of Italy and largely based on a constitution which allowed only members of patrician families listed in the *Libro d'Oro* (the 'Golden Book') to sit in the Great Council. Smaller governmental bodies were elected frequently from the Council and presided over by the all-powerful chairman, the Doge, whose own election was carefully controlled to avoid the pursuit of personal ambition. Leonardo Loredan (1438-1521) was Doge from 1501.

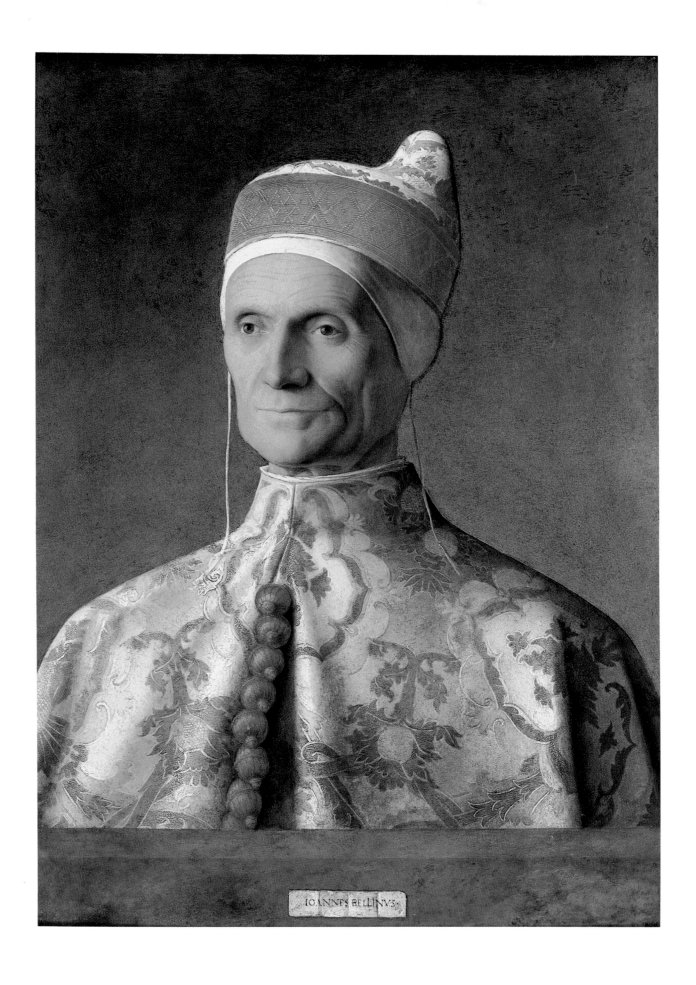

IOANNES BELLINVS.

Ascribed to GIORGIONE (c.1478-1510)
Fête Champêtre

c.1510. Oil on canvas, 110 x 138 cm. Paris, Musée du Louvre

The new mood introduced by Giorgione is exemplified in this picture. The subject is mysterious, the figures, colour and painting are sensual. He was influenced by Leonardo's use of shadows to breathe life into his forms, but, unlike him, was reputed to work directly on to the canvas without the use of preparatory drawings. Leonardo visited Venice briefly after fleeing Milan in 1499. Whereas Bellini, Giorgione's master, bathed his landscapes and figures in light, Giorgione united them with atmosphere, making all the elements equally important. For Giorgione, Man was just one aspect of the cosmos. In this aspect, and in his setting of the figures in, rather than on, the landscape, he compares with Leonardo.

Very few facts are known about Giorgione's short life – he was to die of the plague, caught from his mistress, in 1510 – and the Venetian connoisseur, Marcantonio Michiel identified only fifteen works by Giorgione in his record of pictures in Venetian houses in 1525-43. Vasari tells us that Giorgione was extremely fond of the lute 'which he played so beautifully to accompany his own singing that his services were often used at music recitals and social gatherings'. Some of Giorgione's works were finished by Titian, and it has been suggested that the haunting look of the two men here is closer to Titian's style than to Giorgione's. Titian certainly developed this type of painting in such works as *Sacred and Profane Love* (Rome, Borghese Gallery).

LEONARDO DA VINCI (1452-1519)
Portrait of an Unknown Woman
('The Mona Lisa')

c.1506-8. Oil on panel, 76.8 x 53 cm. Paris, Musée du Louvre

Probably the most famous painting in the world, the *Mona Lisa* was, according to Vasari, a portrait of the third wife of a local merchant named Giocondo. Leonardo spent years on the painting, to the exclusion of more influential patrons. Vasari probably never saw the painting, and even allowing for the discolorations of time, the rosy lips he describes would not have been painted thus by Leonardo. He is more perceptive in his doubtless fanciful story that Leonardo 'employed singers and musicians or jesters to keep her full of merriment and so chase away the melancholy that painters usually give to portraits'. As a result, in this painting 'there was a smile so pleasing that it seemed divine rather than human; and those who saw it were amazed to find that it was as alive as the original'. With 'The Mona Lisa' Leonardo established a new standard for portraiture. Throughout the *quattrocento* artists had made their sitters look like sculpture. Leonardo realized that an element of mystery gave a face verisimilitude and it is the *sfumato* indistinctness of her features which create that 'beauty touched with strangeness'. The portrait is not merely a depiction of the sitter, but an idealized beauty. Behind her, Leonardo has distilled from his observations of natural forms and phenomena an ideal and portentous landscape.

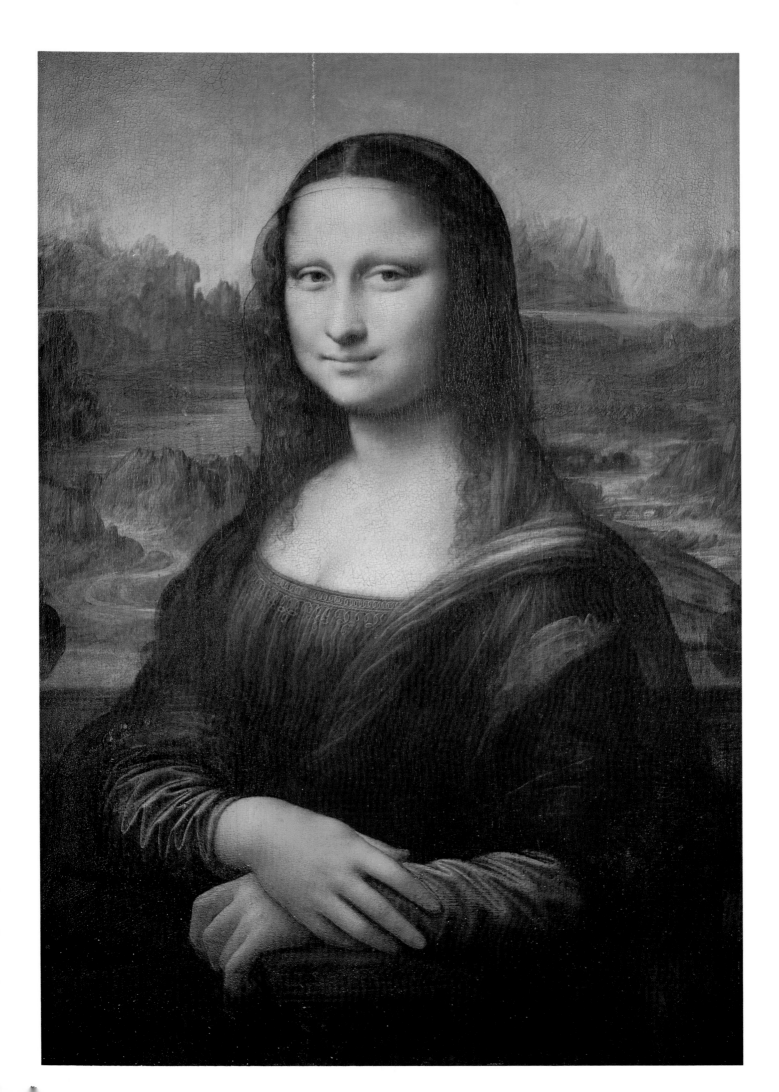

GIOVANNI BELLINI (active c.1459-1516)
and TITIAN (c.1485/90-1576)
The Feast of the Gods

1514. Oil on canvas, 170 x 188 cm. Washington, National Gallery of Art, Widener Collection

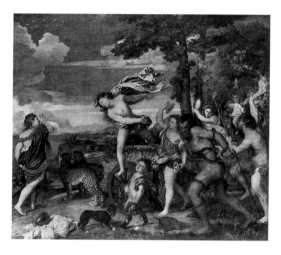

Fig. 31
Titian
Bacchus and Ariadne
1520-22. Oil on canvas,
175.2 x 190.5 cm.
London, National Gallery

Bellini's picture was to have been one of a series commissioned from different artists for Alfonso I d'Este's *Camerino d'Alabastro* in the Castle at Ferrara. The deaths of Fra Bartolommeo in 1517 and Raphael in 1520 prevented the fulfilment of their parts of the commission, and Titian was subsequently employed to complete the room, painting his *Venus Worship* (Madrid) in 1519 based on Fra Bartolommeo's sketch, and later the *Bacchanal of the Andrians* (Madrid) and *Bacchus and Ariadne* (Fig. 31). The decoration of the room was completed by Dosso Dossi, the Ferrarese court painter. Bellini dated his picture 1514 and, although Vasari claimed that Titian completed it because his master was too old, it appears that instead he repainted Bellini's frieze-like landscape to harmonize with his own pictures, which by then dominated the room. X-rays show an interim landscape possibly painted by Dossi.

The subject is taken from Ovid's *Fasti*. Priapus, an ancient fertility god, hoping to ravish the nymph Lotis, crept up on her while she slept during a banquet of the gods. He is seen here lifting her dress, while the folds of his own garment betray his intention. He was foiled by the braying of Silenus' ass, which woke the gods. The subject was an unusually lascivious one for such a deeply religious artist, but towards the end of his life, Bellini began painting more sensual subjects, such as the *Venus at her Toilet* (Vienna), under the influence of the younger Giorgione and Titian.

Titian's source for *Bacchus and Ariadne* was also Ovid's *Fasti*. With its dynamic composition of only a few figures set in a beautiful landscape, Titian managed to suggest the return of the young Bacchus and his boisterous retinue to his wife, Ariadne. The figure struggling with the snake is derived from the *Laocöon* (Fig. 1) and the enamel-like colour reflects the Byzantine richness of Venice.

PIETRO PERUGINO (c.1440/50-1523)
Virgin and Child with Saints

c.1495-96. Oil on panel, 152 x 124 cm. Bologna, Pinacoteca Nazionale

Our Lady and Christ are represented within a *mandorla* (from the Italian for 'almond') which was used to depict the effulgent glory or aureole surrounding the events of Christ's Transfiguration and Our Lady's Assumption. The *mandorla* is supported by the red heads of seraphim and cherubim, the first choirs of angels, and the blue dominions, the second. Whereas the archangels are able to intervene in the affairs of mankind, these two orders remain aloof from mortals. Below, to the right of the Archangel Michael, portrayed as a warrior against the powers of evil, is Saint Catherine, with the symbol of her martyrdom, a broken wheel; to her right stand Saint Apollonia and Saint John the Evangelist with his eagle. Saint Apollonia is depicted holding the pincers with which a rioting mob tore out her teeth; refusing to recant her faith, she threw herself into their fire. Rather than being witnesses to the Assumption, the saints contemplate Our Lady's heavenly state.

This painting is typical of Perugino's serene and pious altarpieces which were particularly admired for their sweetness of style. Although much of his painting was idealized and repetitive, elements which Perugino observed from nature, such as Michael's armour (which like his parade shield is contemporary with the date of the picture) and the landscape background show his debt to Piero della Francesca and northern artists. He is thought to have worked in Andrea del Verrocchio's studio, possibly developing there his use of oil paint to produce rich jewel-like colour.

32 RAPHAEL (1483-1520)
The Virgin and Child with Saint John
the Baptist and Saint Nicholas of Bari
('The Ansidei Madonna')

c.1505. Oil on panel, 209.6 x 148.6 cm. London, National Gallery

Painted for Bernardino Ansidei for the chapel of Saint Nicholas of Bari in
the Servite church of San Fiorenzo in Perugia, this altarpiece reveals
Raphael's debt to Perugino. The juxtaposition of an infant Christ with the
adult Baptist was not uncommon in Renaissance representations. The
Baptist is holding an unusual crystal crucifix, and Saint Nicholas wears his
robes as Bishop of Myra in Asia Minor. Christ sits reading on his mother's
knee; a similarly precocious child, Saint Nicholas had stood up at birth
and praised God. The three golden balls lying at Nicholas' feet represent
the dowries he threw through the window of a house whose owner could
not afford to marry his daughters honourably. (Pawnbrokers, of whom he
is the patron saint, adopted the three gold balls as their insignia.)

Raphael's painting, dated in Roman numerals MDV on the edge of the
Madonna's cloak, is close in style to that of his master Perugino, particu-
larly in the slightly vacuous expression of the Baptist. The clarity of the
architectural forms foreshadows his later work as an architect in Rome, but
there is little here to anticipate the brilliant narrative with which
he enlivened his frescoes in the Vatican Stanze only three years later
(Plate 33).

RAPHAEL (1483-1520)
The School of Athens

c.1509-11. Fresco. Vatican, Stanza della Segnatura

The frescoes in the Stanza della Segnatura (so called because by Vasari's time documents were sealed there) depict theologians disputing the mystery of the sacrament (in the *Disputa*) and Apollo assembled with the poets (in the *Parnassus*). In *The School of Athens*, Raphael depicts the ancient sages set in Bramante's monumental architecture. Not only does every figure play an essential role in the balance of the composition, but the essence of each philosopher is portrayed by his action. Thus, framed in the central arch, Aristotle gestures to the ground, symbolizing the empirical science on which his philosophy is based, and Plato points upwards, emphasizing the other-worldly basis of his thought. Socrates, ticking off questions on his fingers, is linked to them by his *contrapposto* pose, which reflects that of the youth in white. The calm, upright pose of the young man directly below balances the group around Pythagoras. On the right, Ptolemy holds a terrestrial globe and Zoroaster a celestial one, while a group watch Euclid (supposedly a portrait of Bramante) propounding a theorem. Diogenes sprawls on the stairs, isolated from the others and the world. Heraclitus, who also turns his back on the world, links the figure of Diogenes and the group around Euclid with those at the top of the stairs. Raphael included a self-portrait on the far right. Only the pensive figure in the foreground is not present in the drawing (Fig. 32), and gives substance to Vasari's stories of Raphael's clandestine visits to Michelangelo's Sistine ceiling, which seems to have inspired this additional figure's mood of grave contemplation.

Fig. 32
Raphael
Cartoon for 'The
School of Athens'
1510. Charcoal, black
chalk, white heightening
on many sheets of paper,
280 x 800 cm. Milan,
Ambrosiana

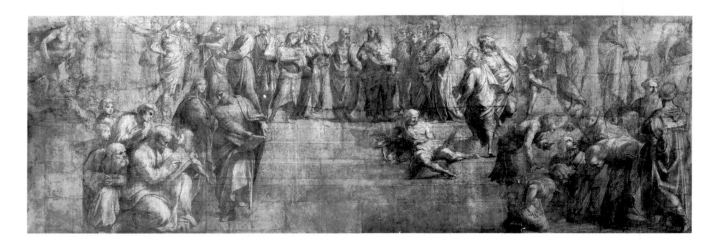

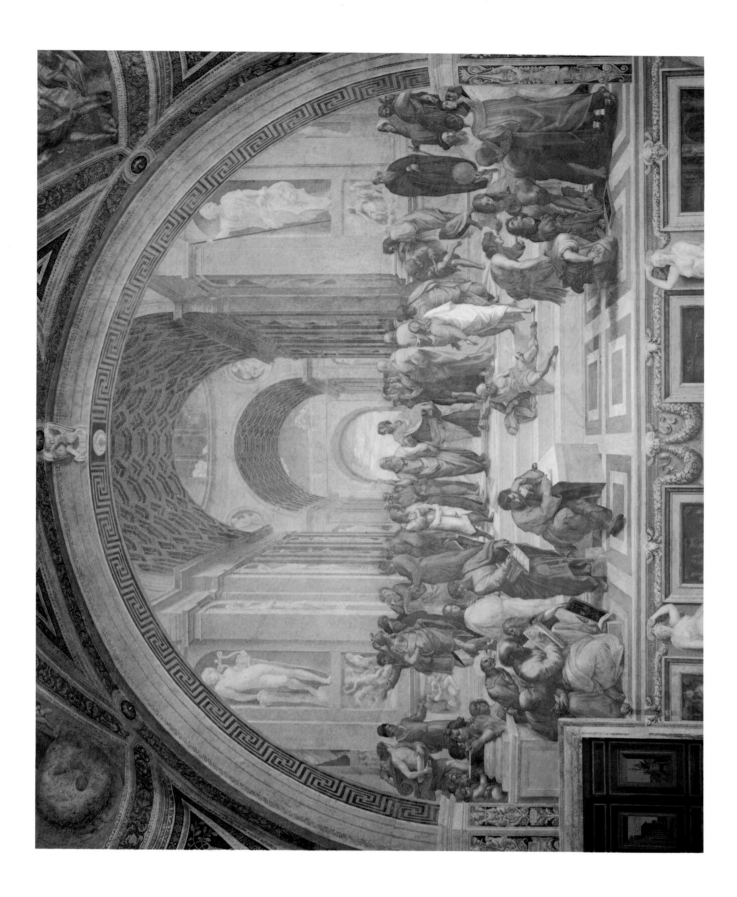

MICHELANGELO (1475-1564)
The Holy Family ('The Doni Tondo')

c.1504. Oil on panel, 120 cm diameter. Florence, Uffizi

Commissioned by a Florentine banker, Angelo Doni, who was also a patron of Raphael, this *tondo* is one of Michelangelo's rare easel pictures. His preference for sculpture is evident in the plastic forms and unity of the figure group, which appear as though carved from a single block of marble. The grouping of the Holy Family shows the influence of Leonardo's cartoon of *The Virgin and Child with Saint Anne* which had gone on public view in 1501, and in which he tackled the problem of composing a group of interrelating figures. Michelangelo's awkward, foreshortened poses were similarly chosen to show his virtuosity. The Holy Family are separated by a parapet from the naked youths representing the antique world (rather than the Old Testament world) over which Christ triumphed. An infant John the Baptist turns away from the youths to look adoringly at Christ.

In his *Entombment* (Fig. 33) of 1507, Raphael relied heavily on Michelangelo's own unfinished *Entombment*, the Doni Tondo and the *Pietà* (Fig. 17), elements of which he combined with a knowledge of Mantegna's engravings of the subject and antique sculpted reliefs of *The Death of Meleager*.

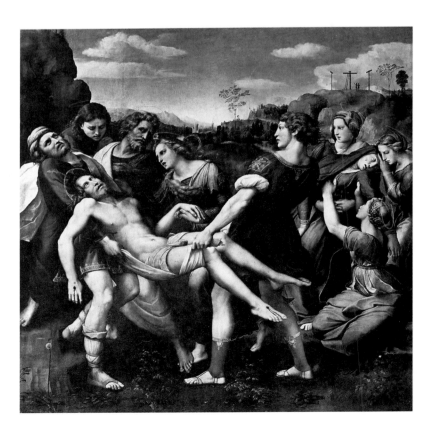

Fig. 33
Raphael
The Entombment
1507. Oil on panel,
184 x 176 cm. Rome,
Borghese Gallery

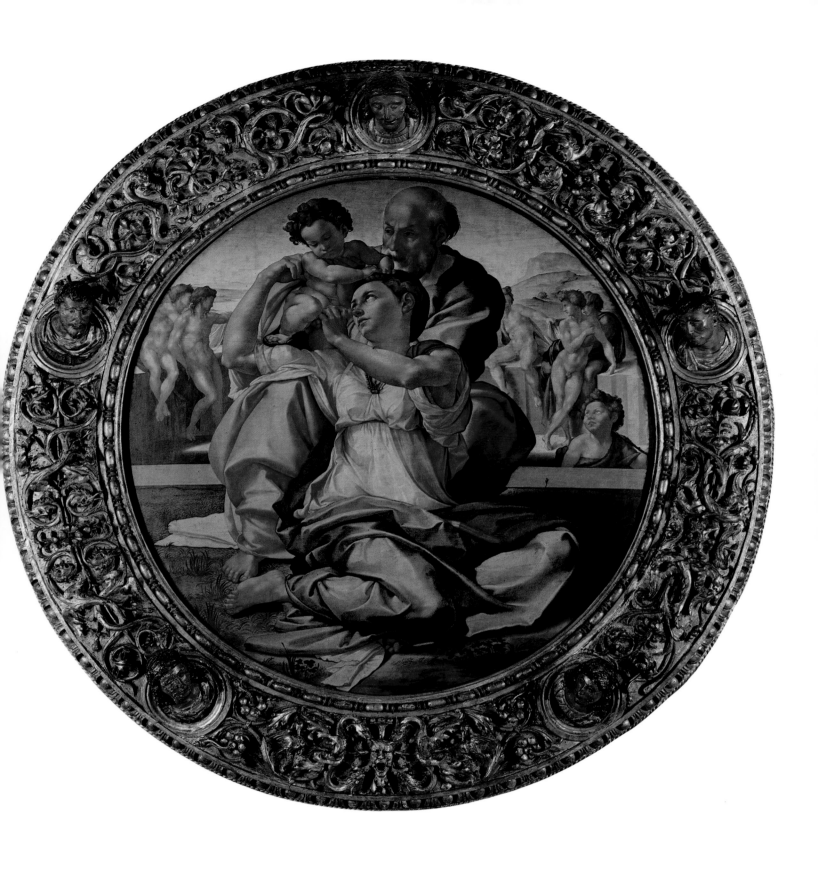

GIORGIONE (c.1478-1510)

The Tempest

c.1506-8. Oil on canvas, 83 x 73 cm. Venice, Accademia

Marcantonio Michiel described *The Tempest* in 1530 as 'a small land-scape...with the storm, and the gypsy and soldier'. It is perhaps from this description that the man is always known as a soldier, although he does not carry a lance, merely a staff, and only his slashed breeches suggest that he might be a *Landsknecht* (a German mercenary). We know that Giorgione composed directly on to the canvas and X-rays have revealed the figure of another nude woman under the soldier's feet: the mysterious subject evolved as he painted, and much of the atmosphere created was through the use of aerial rather than linear perspective. Perhaps the picture represents the elements, earth, water, air and fire (the lightning); or the senses, sight, sound (the thunder), touch, taste and smell (perhaps the rose); or it may have been a challenge to Pliny's description of the classical painter, Apelles, painting the unpaintable – a thunderstorm. It is a painting which has been subjected to many allegorical interpretations, but essentially it is an intensely lyrical landscape of mood, a dream picture, if not of a Golden Age, then certainly satisfying Horace's dictum, *Ut pictura poesis* (as in poetry so in art).

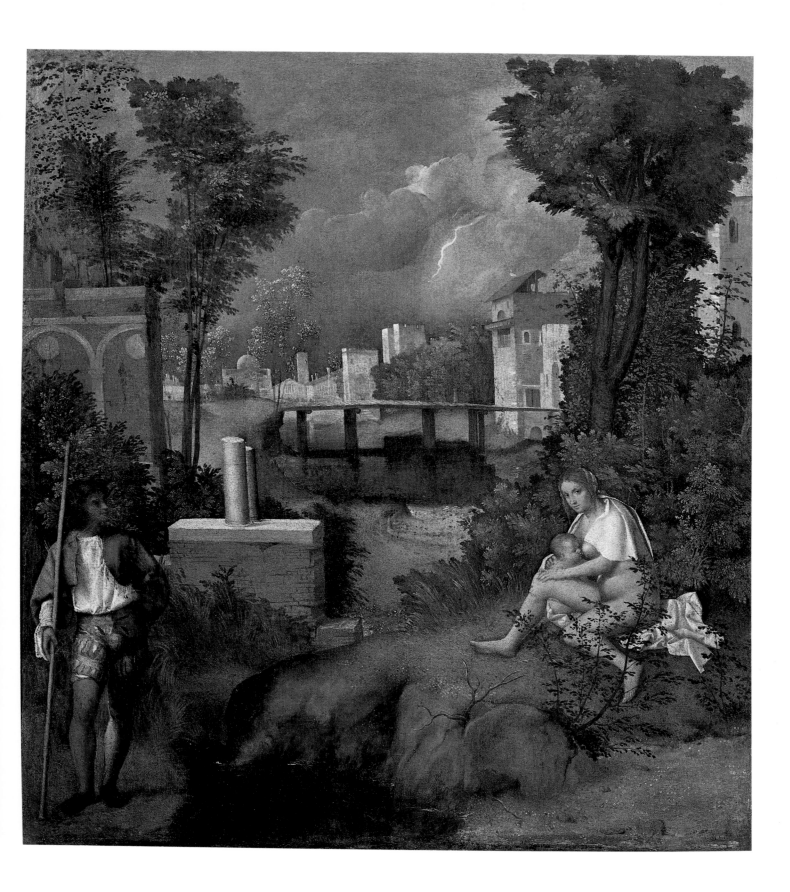

LORENZO LOTTO (c.1480-1556)
Portrait of Andrea Odoni

1527. Oil on canvas, 101.5 x 114 cm. Hampton Court, Royal Collection (reproduced by gracious permission of Her Majesty the Queen)

Andrea Odoni lived in a palazzo known among connoisseurs on the Fondamenta del Gaffarro. The inventory made by Marcantonio Michiel five years after this portrait was painted describes the house of a man with a passion for the antique. The portrait hung in Odoni's bedroom which was furnished with a bed painted by Savoldo and an allegorical painting by Palma Vecchio. Next door in his study was a collection of porphyry and crystal cups and vases made from semi-precious stones. The floor below was filled with draped classical statues, a Roman bust and mutilated stone heads and statuettes (although it is unlikely that these were propped up in quite such a casual way as the head of the Emperor Hadrian seen here). In the courtyard stood two colossal sculptures after the antique, and heads of Hercules and Cybele by Antonio Minelli. However, this portrait is not about the pride of possession. Lotto often caught his sitters in off-guard moments of self-revelation; here Odoni holds a statuette of Diana of the Ephesians in his hand, and it has been suggested that the picture represents the opposition of Art to Nature (the latter represented by Diana). The statuette was clearly of significance to the sitter, but exactly how it reflected his state of mind is not certain.

During the seventeenth century the painting was in Holland, where it influenced both van Dyck and Rembrandt.

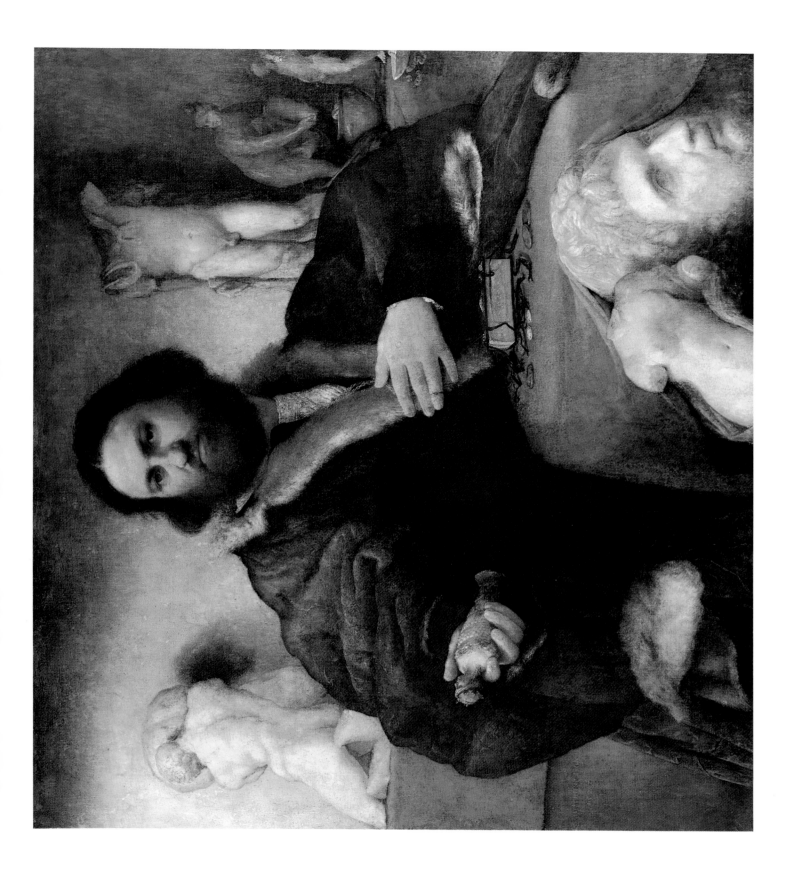

MICHELANGELO (1475-1564)
The Creation of Adam

1511-12. Fresco. Vatican, Sistine Chapel

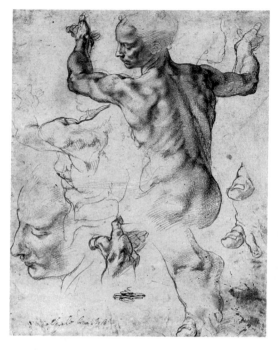

Fig. 34
Michelangelo
Studies for the
Libyan Sibyl
c.1510. Black chalk,
28.9 x 21.3 cm. New York,
Metropolitan Museum of
Art (Purchase, 1924, The
Joseph Pulitzer Bequest)

In the centre of the Sistine Chapel, Michelangelo depicts not the creation of Adam's flesh but the electrifying moment when he receives his soul. Like Giotto and Masaccio, Michelangelo did not create elaborate settings for his figures, but allowed their simple, powerful gestures to create the impact. Having been able to view his work from below, Michelangleo painted the second half of the ceiling in a broader format than the earlier scenes.

Michelangelo divided the vast ceiling of the chapel into five large and four small rectangles, in which he depicted the biblical story from the Creation to Noah. Figures of breathtaking beauty, the *ignudi* (the so-called 'young athletes'), framed the panels at each corner. In the lunettes above the chapel windows he depicted the ancestors of Christ, and between these stood the vast figures of prophets and sibyls (Fig. 34). Above the altar the artist painted one of the most inventive compositions of the Renaissance, a testament to Michelangelo's genius, *God dividing form from chaos*.

Michelangelo painted many of his frustrated ideas for Pope Julius II's tomb on the ceiling, combining classical elements and Christian subject-matter – for example, Adam is based loosely on a Roman river god, and it is possible that the *ignudi* represent a neo-Platonic concept of Ideal Man. All the paintings in the chapel revolved around a unified iconographic scheme: the ceiling depicts the world before the Mosaic dispensation, the Florentine frescoes of the 1480s parallel the lives of Christ and Moses, and the tapestries, commissioned from Raphael by Pope Leo X in 1515, portray the Establishment of the Church and the Acts of the Apostles. *The Last Judgment* on the altar wall (Fig. 18), painted later in Michelangelo's life, shows a change in the character of his profound religious belief, from optimism expressed in the ceiling to pessimism.

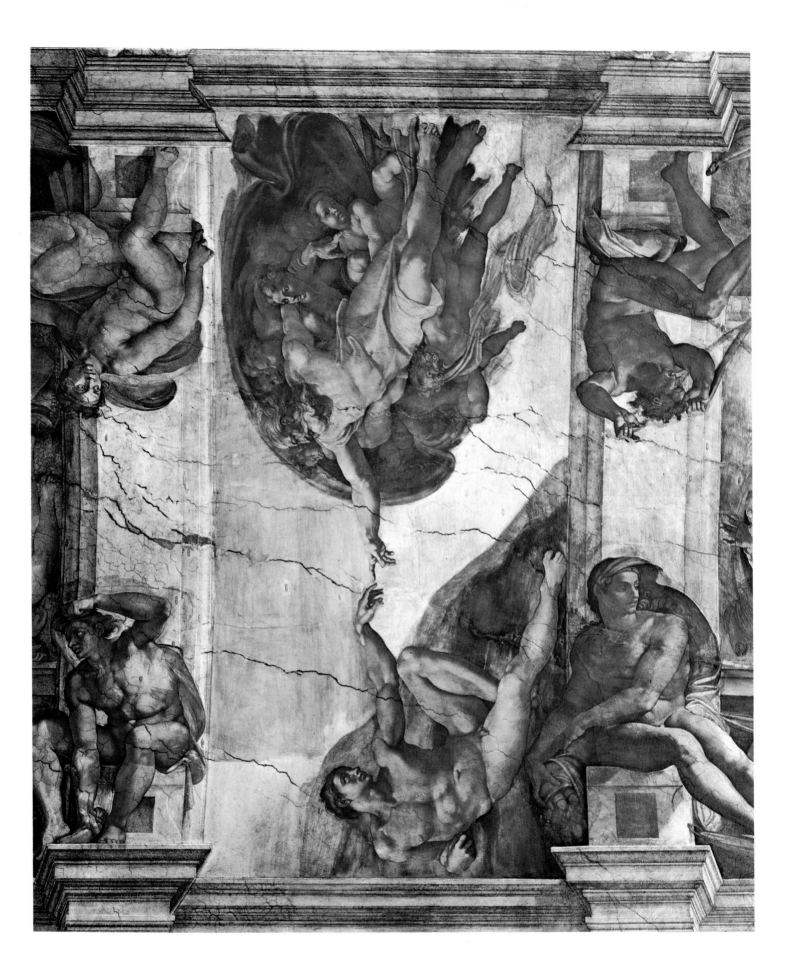

JACOPO PONTORMO (1494-1556)
Joseph in Egypt

c.1515. Oil on panel, 96.5 x 109.5 cm. London, National Gallery

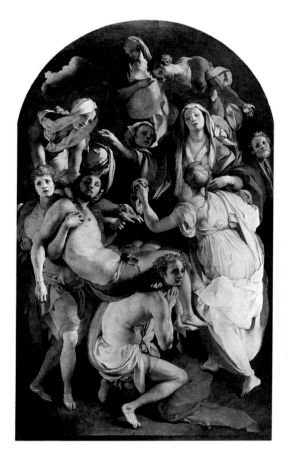

This painting was one of a series made for the bedroom of a Florentine gentleman, Pier Francesco Borgherini. Three more panels for the commission by Pontormo exist, and others executed by Andrea del Sarto, Granacci and Bacchiacca. According to Vasari the whole series was commissioned by Borgherini's father for his son's marriage in 1515.

Here, in a startlingly innovative composition, Pontormo portrays four episodes from Joseph's life. Identified throughout in a brown tunic and mauve cloak, Joseph is seen on the left presenting his father, Jacob, then aged 130, to the Pharaoh of Egypt, while on the right, in some sort of triumphal car, he listens to the petition of the crowd for food (Joseph saved Egypt from famine). He is next seen climbing up the strange staircase with one of his sons and, finally, presenting both sons, Manasseh and Ephraim, to his dying father, then aged 147. Pontormo depicted his pupil, Bronzino (later to become a painter, Plate 42), whom he looked after almost as an adopted son, as a small boy with a basket sitting on the steps. The strange buildings are not unlike those developed by the Mannerist architects whose apparently unsupported structures give rise to feelings of unease. The distictly northern arch in the background is taken from a print by Lucas van Leyden of 1510.

Pontormo's was perhaps the most extreme form of Florentine Mannerism, combining as it does distortions of space, time and figures with masterly draughtsmanship. He worked a great deal for the Medici, in particular decorating their villa at Poggio a Caiano.

Fig. 35
Jacopo Pontormo
The Deposition
1526-28. Oil on panel,
313 x 192 cm. Florence,
Santa Felicità

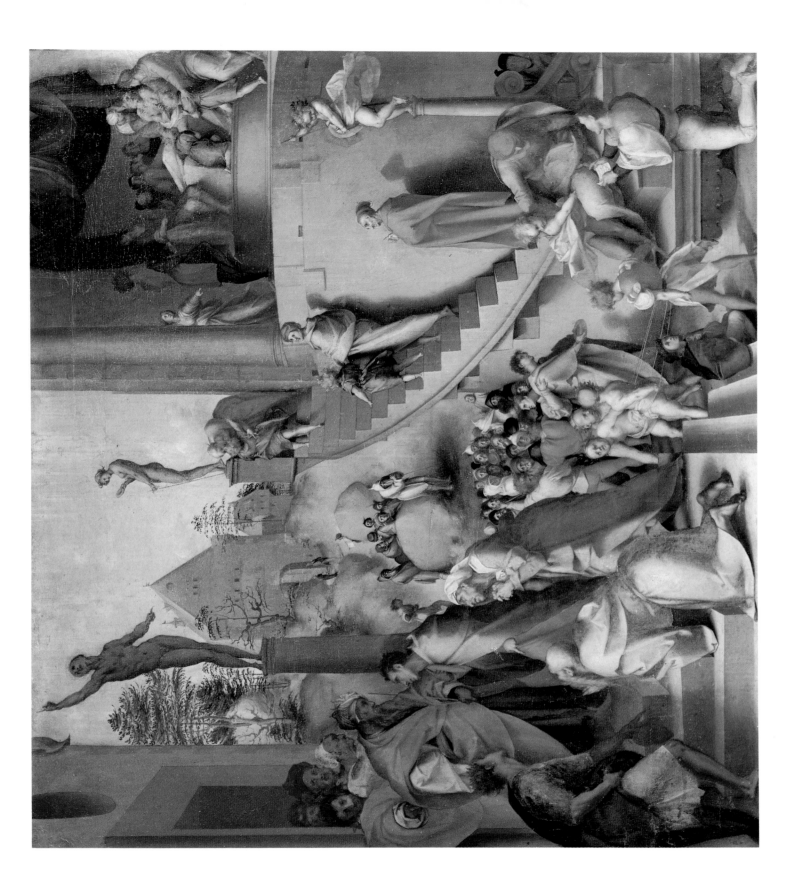

PARMIGIANINO (1503-40)
The Mystic Marriage of Saint Catherine

c.1530. Oil on panel, 74.2 x 57 cm. London, National Gallery

In her role as one of the 'fourteen holy helpers', Saint Catherine of Alexandria was extremely popular in the Middle Ages during times of plague. Her story is related in the *Golden Legend*, although her actual existence is doubted. Supposedly the half-niece of Constantine the Great, she became a queen. A hermit saw Our Lady in a vision, ordering him to tell Queen Catherine that her husband would be Jesus. Catherine is seen here at her betrothal with Christ. This previous engagement prevented her from marrying the Emperor Maxentius, who cast her into prison, where she was brought food by angels. His intention to slay her with spiked wheels was confounded when the wheels fell apart at her touch. (One of these wheels is depicted here; Catherine is still commemorated by the fireworks which bear her name).

Parmigianino went to Rome in 1524 where he encountered Rosso Fiorentino, Giulio Romano and Perino del Vaga. These last two had worked in Raphael's studio and developed the Mannerist tendencies of Raphael's late work. Unlike earlier Renaissance painters, whose work would depict a subject in narrative form, the Mannerists' work was more suggestive or symbolic. Here, Parmigianino's seemingly dissonant picture consists of carefully related curves – the window, the wheel and the curtain. The head of the old man (a *repoussoir* feature, drawing the onlooker's attention into the picture), possibly Saint Joseph, serves to place the hands of the betrothed not only in the centre of the picture vertically, but also in depth, being half-way between the picture plane and the two figures in the doorway. Passages of great beauty and delicacy, such as the lost profile of Our Lady and Saint Catherine's hands, reveal Parmigianino as a draughtsman of great skill.

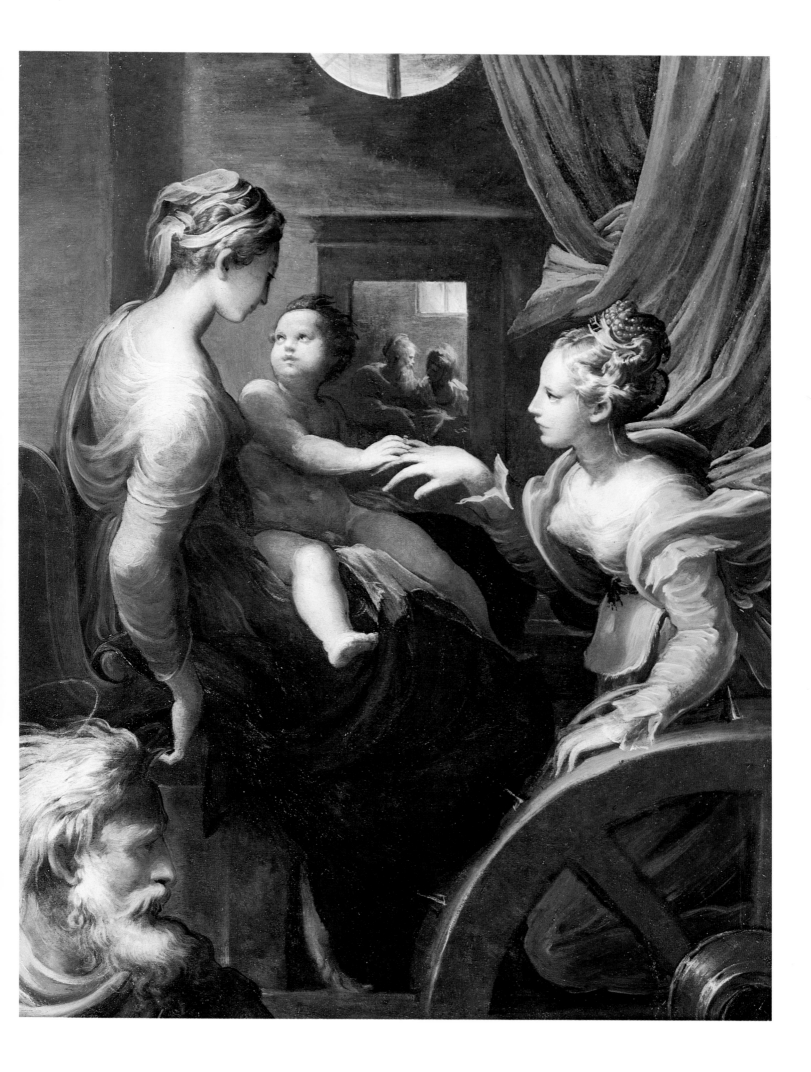

ANTONIO CORREGGIO (1494-1534)
Jupiter and Io

40

c.1530. Oil on canvas, 163.5 x 74 cm. Vienna, Kunsthistorisches Museum

Jupiter and Io is perhaps the erotic masterpiece of the Renaissance. Correggio's portrayal of Jupiter's disguise here is stunning. The softness he developed in his painting is a far cry from the crisp style of Mantegna, whose pupil he is believed to have been, and discloses the deep influence of Leonardo. The dramatic lighting of his works and the voluptuousness of his forms was to be a great influence on the painters of the Baroque.

Painted for Federigo Gonzaga and given by him to the Emperor Charles V, probably on his second visit to Mantua in 1532, this picture was one of a series depicting four Loves of Jupiter: Io, Ganymede, Danaë and Leda. In each of them the versatile Jupiter changed his form to conceal his infidelity from his wife Juno; as an eagle he carried off Ganymede, as a shower of gold he seduced Danaë and with Leda he took the form of a swan. Here, for Io, the daughter of Inachus, the King of Argos, Jupiter transformed himself into a cloud, his human face just visible. Juno's revenge was to turn Io into a heifer condemned to wander and be plagued by the gadfly.

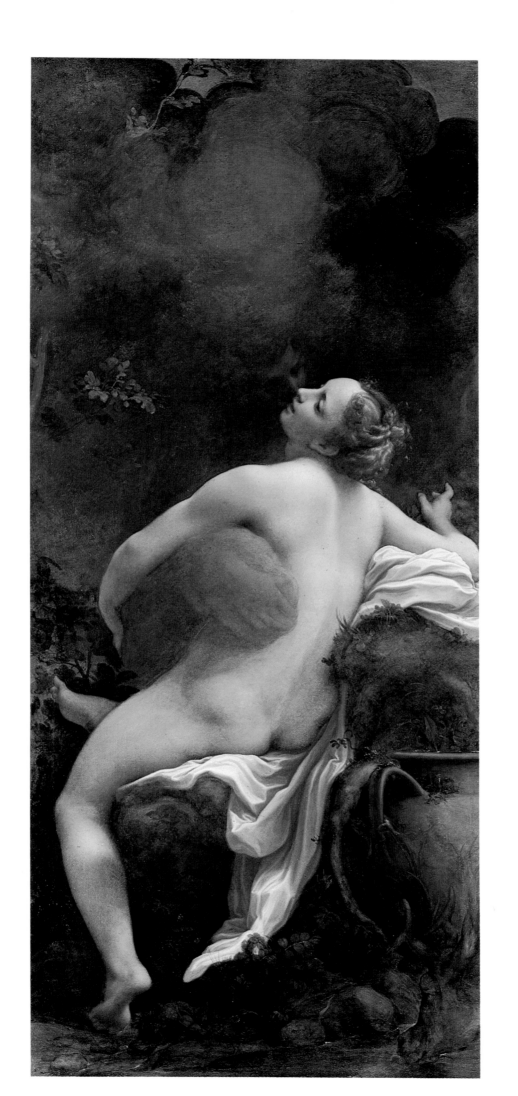

ROSSO FIORENTINO (1495-1540)
Moses and the Daughters of Jethro

c.1520. Oil on canvas, 160 x 117 cm. Florence, Uffizi

This is unlikely to be the picture of Moses slaying the Egyptian which Vasari says Rosso painted for Giovanni Bandini, as the episode depicted is later in the story of Moses. Having slain an Egyptian who was maltreating an Israelite, Moses fled to the land of Midian. When the daughters of Jethro, Priest of Midian, came to draw water for their sheep at the well where Moses was sitting, other shepherds tried to drive them away, but Moses defended the girls and later married one of them, Zipporah. Rosso's picture portrays a violence in excess of that demanded by the story. His fascination with the nude is clearly expressed, and perhaps substantiates Vasari's claim that Rosso disinterred dead bodies in the interests of studying anatomy.

Painted in Rome, the picture reflects in particular the influence of Michelangelo's nudes and of the other Roman Mannerists. In Raphael's work too, there can be found similar passages of densely packed nude figures in violent or dramatic poses: the desperate figures in the *Fire in the Borgo* (Fig. 36), the possessed boy in the *Transfiguration*, and the frenzied mythological figures in his decorations for Agostino Chigi. In this brutal picture it is the claustrophobic space that is characteristically Mannerist. Later, in Fontainebleau, where he worked for King Francis I of France, Rosso was to develop a more fantastic art with attenuated figures.

Fig. 36
Raphael
Fire in the Borgo
1514. Fresco. Vatican

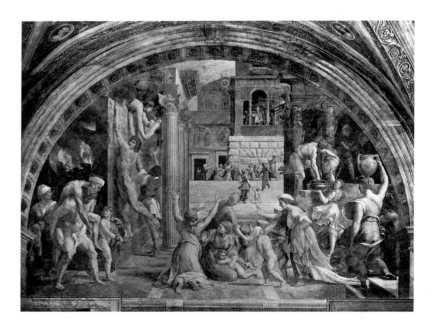

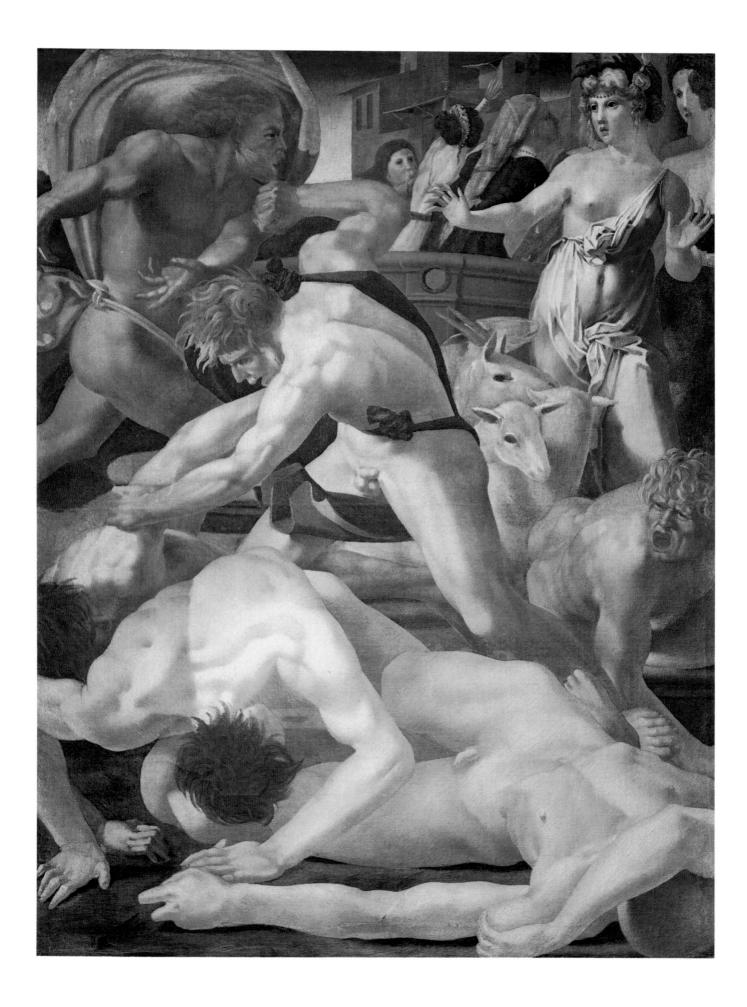

BRONZINO (1503-72)
An Allegory

c.1545–46. Oil on panel, 146 x 116 cm. London, National Gallery

From 1539 until his death, Bronzino was the court painter for Cosimo I de'Medici and his wife, Eleanora of Toledo. In this picture, Bronzino presents a complicated allegory which has been interpreted by Erwin Panofsky as a warning to those who indulge in merely sensual love that its consequences are despair and jealousy. Contemporary interpretations of the allegory are confused, as the picture was sent to France very soon after being painted. Time and Truth remove a curtain to reveal Venus and Cupid, who symbolize sensuality. Cupid treads on the doves of conjugal fidelity while to his left, the Medusa-like figure of Jealousy tears at her hair. On the right, Folly showers them with flowers and behind him crouches a beautiful girl, with the hind-quarters of an animal and a tail ending in a scorpion's sting. She presents the lovers with honeycomb, but holds her sting in her other hand. She is Deceit personified, both in her ambiguous appearance and in the gift she offers.

Bronzino's patrons would have enjoyed his quotations from the works of the great masters. From Michelangelo's Doni Tondo (Plate 34) come the pose of Venus and the head of Time, while the masks at Venus' feet appear in Michelangelo's sculpture of *Night* in the New Sacristy of the church of San Lorenzo in Florence. The head of Jealousy is taken from the Pollaiuoli and Leonardo's *Battle of Anghiari* (Fig. 15). The depiction of hair and the scaly flesh of Deceit's tail are typical of the later Mannerists, as are the compressed space and twisted bodies (particularly the curiously long necks of Cupid and Deceit), the elegant profile of Truth and the twisted gestures of the hands.

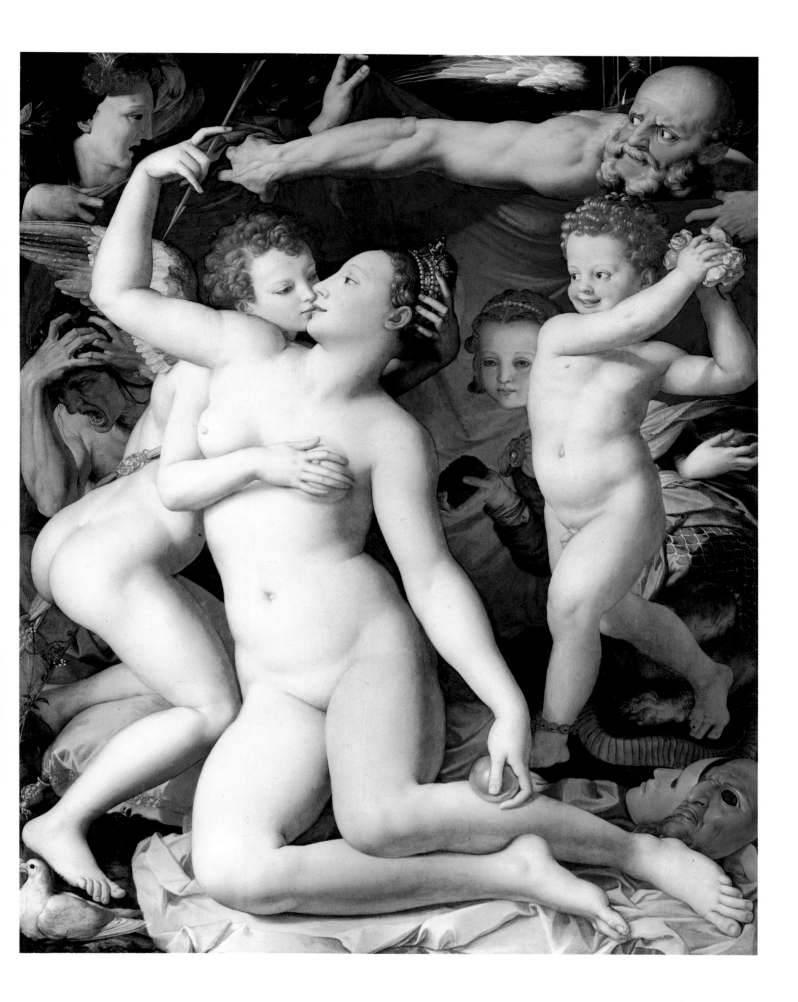

43

GIOVANNI BATTISTA MORONI
(active 1546/7-78)
Portrait of a Man ('The Tailor')

c.1570. Canvas, 97.8 x 74.9 cm. London, National Gallery

Moroni was an artist from Bergamo, in northern Italy, whose output consists mostly of portraits. This is an exceptional, and puzzling, example. It was very rare to depict a craftsman in a portrait, although the figure's clothes are neither those of an artisan nor the nobility, but of the middle class. The sitter's identity is unknown.

Moroni's training under Moretto in Brescia made him sensitive to the art of northern Europe, in particular the full-length portrait which he introduced before Titian had mastered the format (and for which the only precedent was Carpaccio's *Portrait of a Knight* in the Thyssen Collection, dated 1510). After his early exuberant portraits, characterized by the depiction of sumptuous clothing, Moroni was influenced by Spanish art, and his portraits became more penetrating. It is to this period that *The Tailor* belongs. Its subdued colour and lighting prefigure the work of Velasquez, and its unconventional subject relates to the Carracci family's realistic depiction of artisans.

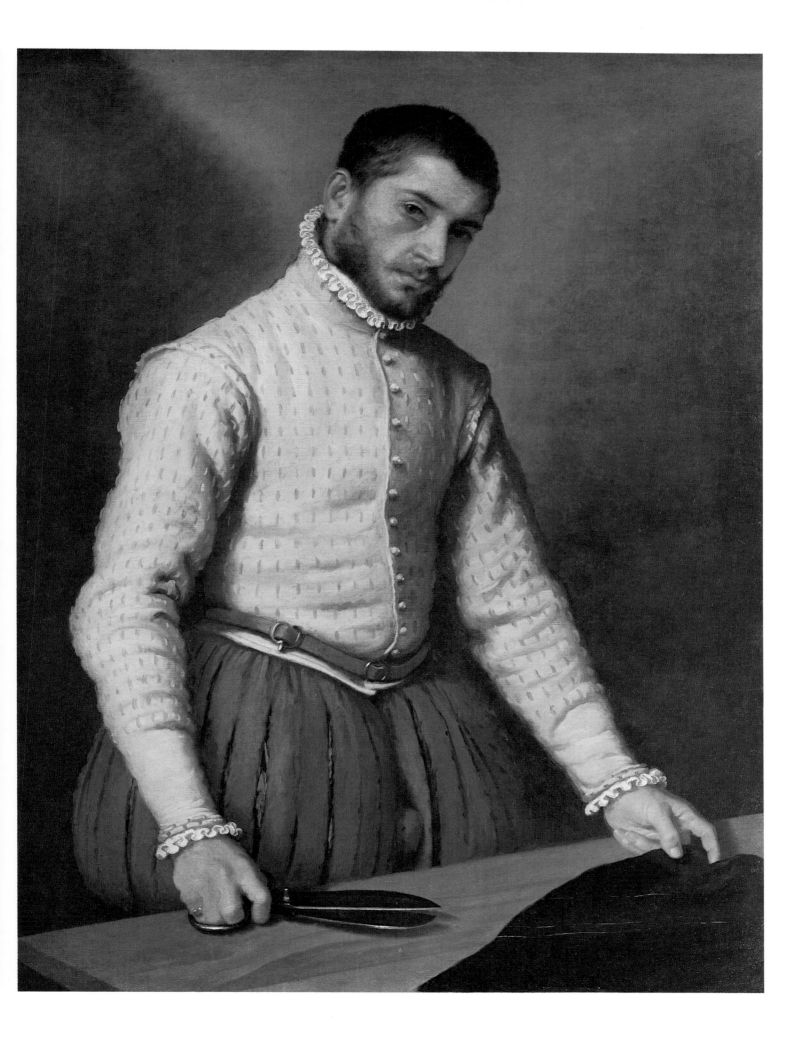

TITIAN (c.1485/90-1576)
Pope Paul III and his Grandsons

1546. Oil on canvas, 200 x 173 cm. Naples, Galleria Nazionale di Capodimonte

In April 1543 Titian met the Farnese Pope, Paul III, at Bologna. He painted him alone two years later, and again with his grandsons in 1546. The Italian word *nipote* means both nephew and grandson, but, as with many pre-seventeenth-century popes, Paul III did indeed have grandsons. Despite his moral lapses, Paul III was a pope of power and vision, who reasserted the strength of the Papacy in the face of the Protestant Reformation. He summoned the Council of Trent that sat from 1545-63; in 1542 he sanctioned the introduction into Italy of the Inquisition, whose investigations of the content of Veronese's religious work are well known; and in 1540 he approved the Society of Jesus whose Order had been founded in Paris by Saint Ignatius Loyola. These three innovations were to have a dramatic effect on both religion and art in the next century.

On the left of the old Pope stands Cardinal Alessandro Farnese (1520-89) and on the right, Ottavio Farnese (1524-86). It has been suggested that the picture represents a power struggle in the Farnese family, although Titian would not have had the audacity to portray such an issue openly. Instead he has used the device of something being presented, frequently employed in altarpieces to activate a group of figures. Here, Ottavio brings a message, interrupting Paul's conference with Alessandro. Ottavio, whose pose is brilliantly adapted from the antique sculpture the *Discobalus* (*The Discus Thrower*), leans forward the better to hear the old man's notoriously soft voice. The portrait was never finished and reveals Titian's method of building up his pictures on the canvas (see Plate 47).

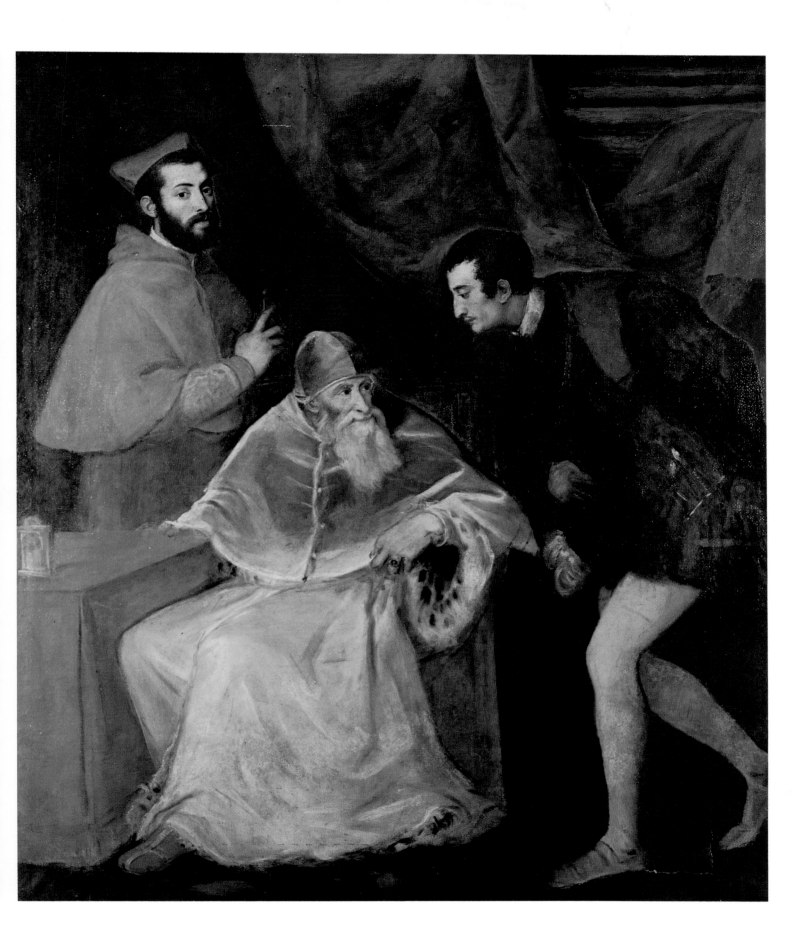

JACOPO TINTORETTO (1518-94)
Saint George and the Dragon

c.1560-70. Oil on canvas, 157.5 x 100.3 cm. London, National Gallery

Saint George was a Roman centurion from Cappadocia. According to the *Golden Legend*, on his travels through Libya he came across a city terrorized by a dragon (the medieval symbol for evil) which required the daily sacrifice of a maiden. The girls were chosen by lottery, and the king's daughter Cleodolinda was to be the next victim. George overcame the dragon, who was then led back to the city by Cleodolinda's girdle. At the sight, all 15,000 citizens became Christians. Saint George is the patron saint of Venice, amongst other places.

Tintoretto's depiction of the scene is traditional enough, with Saint George on his white charger in combat with the dragon on the sea-shore outside the city walls. As so often in Tintoretto's work, the main action is not taking place in the foreground. The whole composition reflects the ferocity of the fight, and the flight from it of Cleodolinda – the trees, the water and the sky are all in turmoil. Although the dragon's chosen fare was maidens, Tintoretto has included the dead body of a man; perhaps he had attempted a previous rescue, but without the help of God, who appears in the sky to manifest his protection of Saint George.

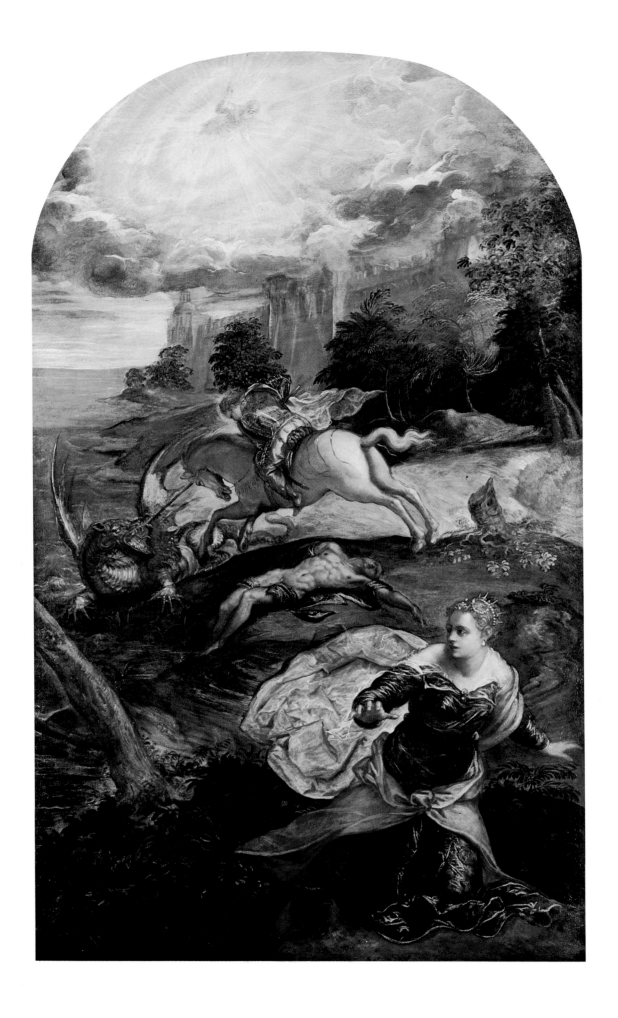

JACOPO TINTORETTO (1518-94)
Susanna and the Elders

c.1570. Oil on canvas, 146.6 x 193.6 cm. Vienna, Kunsthistorisches Museum

Throughout the Renaissance the story of the triumph of Susanna's inno-
cent virtue over villainy provided an opportunity to paint the female nude
while retaining an element of edifying symbolism. The story of the unfor-
tunate Susanna's bath is found in the apocryphal Book of Daniel. She was
the wife of a prosperous Jew living during the exile in Babylon. She was
desired by two Elders of that city, who plotted to seduce her while she
was bathing in her garden. They planned to denounce her as an adulteress
(a crime punishable with death by stoning) unless she lay with them.
Susanna of course refused, the Elders carried out their threat, and she was
condemned to death. Daniel proved her innocence by cross-examining
the Elders, who gave different accounts of her supposed adultery, and
were then themselves condemned to death.

Tintoretto's composition is at its most inventive here, virtually includ-
ing the spectator in the action. The devious Elders are to be found at
curious angles at either end of a rose-clad fence, about to make their
attack. Tintoretto shows a truly Venetian sensuality in the colouring, his
depiction of the fall of light on Susanna's naked body, and the still life of
her jewels and discarded clothes, while Susanna's pose reflects his interest
in Michelangelo. The delightful landscape is painted with tremendous
charm and freedom, providing a decorative frieze or backdrop to the
action.

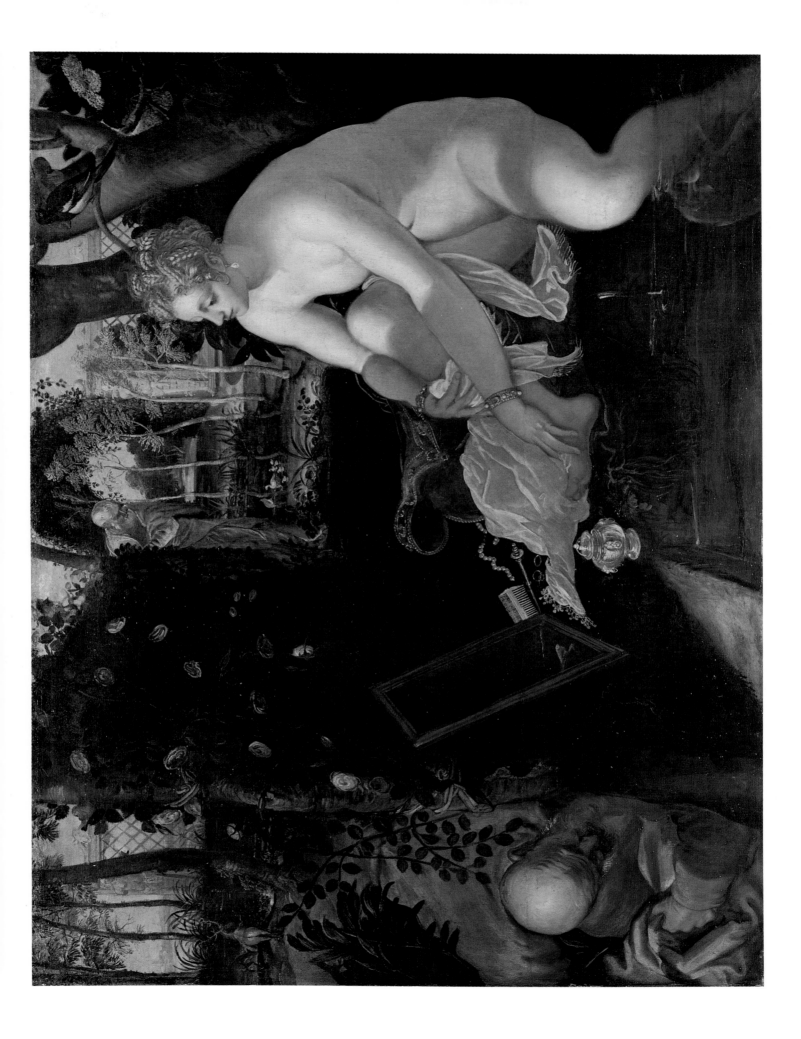

TITIAN (c.1485/90-1576)
Diana and her Nymphs Surprised by Actaeon

c.1556-59. Oil on canvas, 188 x 203 cm. Edinburgh, National Gallery of Scotland
(on loan from the Duke of Sutherland)

Ovid described the tragic mistake made by the young prince Actaeon, who stumbled on Diana, the virgin huntress and symbol of chastity (identified by her crescent moon), bathing in her secret pool. The goddess' nymphs tried to conceal her, but furious at Actaeon for his glimpse of her divine nudity, Diana turned him into a stag to be hunted to death by his own hounds.

Titian's most powerful patron in his later life was Philip II of Spain, for whom he painted this as part of a series of *poesie* and altarpieces. Palma Giovane described Titian's late method of working: 'He laid in his pictures with a mass of colour which served as a groundwork for what he wanted to express. I myself have seen such vigorous underpainting in plain red earth [*terra rossa*] for the half-tones, or in white lead. With the same brush dipped in red, black, or yellow he worked up the light parts and in four strokes he could create a remarkably fine figure ... [Thus] by repeated revisions he brought his pictures to a high state of perfection and while one was drying he worked on another ... The final touches he softened, occasionally modulating the highest lights into the half-tones and local colours with his finger; sometimes he used his finger to dab a dark patch in a corner as an accent, or to heighten the surface with a bit of red like a drop of blood. He finished his figures like this and in the last stages he used his fingers more than his brush ...'

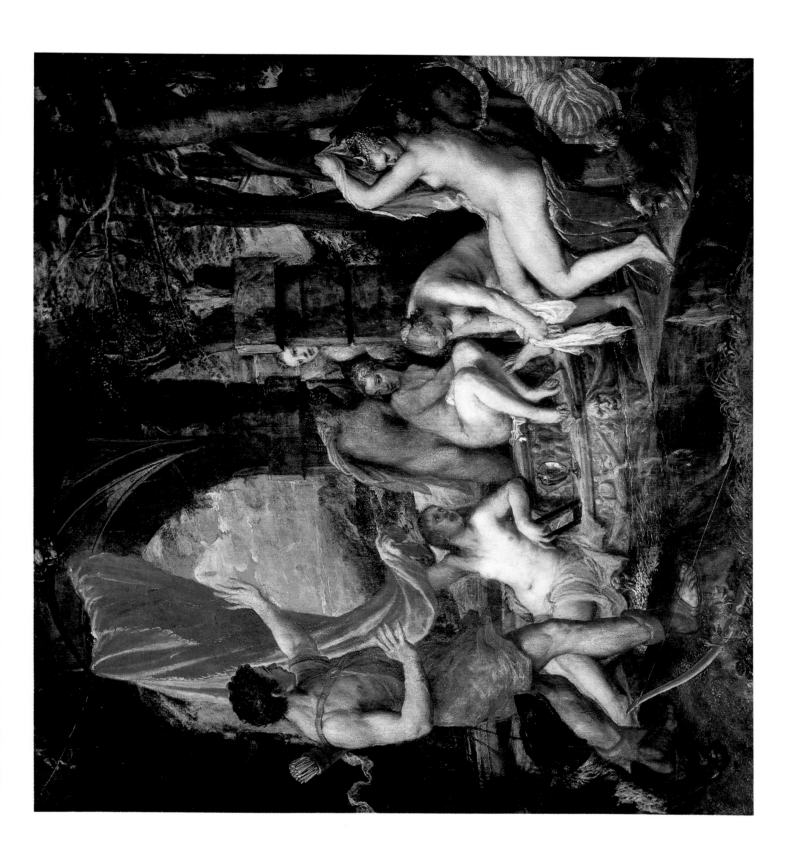

PAOLO VERONESE (c.1528-88)
Mars and Venus United by Love

c.1570-80. Oil on canvas, 205.7 x 161 cm. New York, Metropolitan Museum of Art (Kennedy Fund, 1910)

Venus, married to Vulcan, the blacksmith of the gods, fell in love with Mars, the god of war. Her infidelity was witnessed and reported by the sun-god, Apollo, to Vulcan. The cuckolded husband forged a net under which the lovers were captured. Here Veronese represents the lovers as an allegory of beauty and valour – the conquest of Strife by Love. The putti tie their legs together and keep Mars' horse at bay, so that he cannot abandon Love for War.

There were few classical sculptures in Venice during the Renaissance, although the Horses of Saint Mark of course appeared, as here, as the universal model for horses in Venetian art. Nevertheless, Veronese's knowledge of the antique was clearly extensive and he had probably visited Rome in 1560. The pose of Venus is taken from an antique sculpture, possibly that known as the standing hermaphrodite (whose arms had been restored so that one hand was at the breast). Mars' left arm is taken either from Raphael's *Entombment* or Michelangelo's *Pietà* (Fig. 17), but the draperies, armour and landscape were painted with a sumptuousness that was Veronese's hallmark.

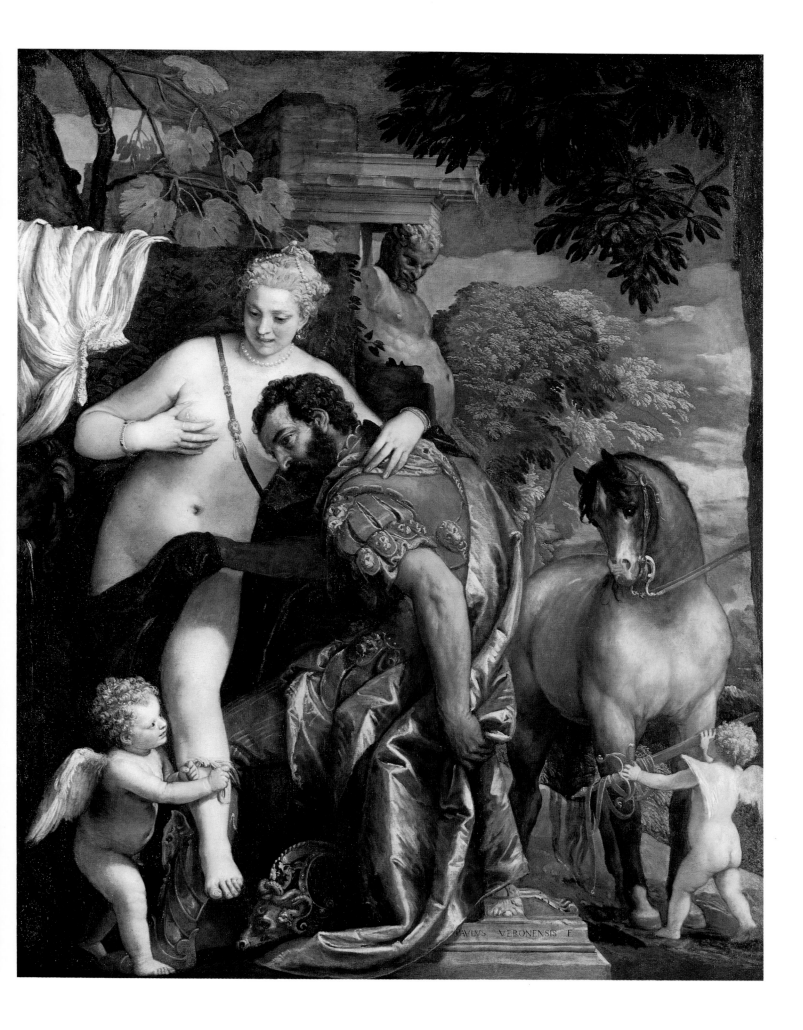

PAVLVS VERONENSIS F